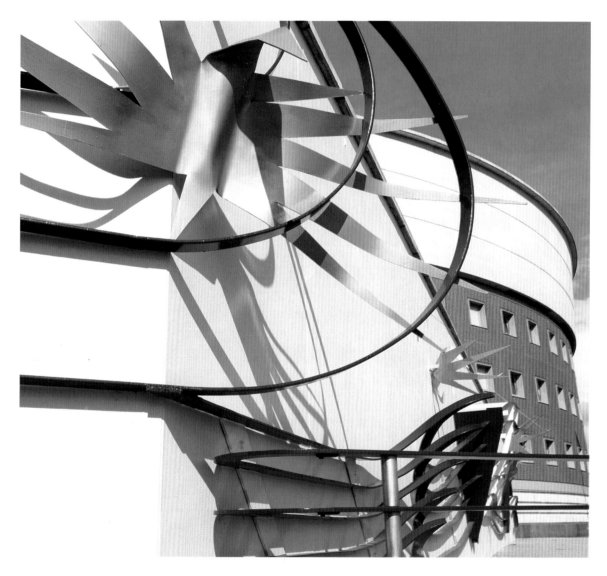

Belfast

Previous page: The Waterfront Hall, with Susan Crowther's
sculpture *Lagan Symphony* in the foreground

These pages: Belfast from the Cavehill

First published in 2001 by
The Blackstaff Press Limited
Wildflower Way, Apollo Road, Belfast BT12 6TA, Northern Ireland
© Photographs, Christopher Hill Photographic, 2001
All rights reserved
Printed by Betaprint
A CIP catalogue record for this book is available
from the British Library
ISBN 0-85640-708-9

Belfast

Chris Hill
Jill Jennings

THE
BLACKSTAFF
PRESS

BELFAST

Introduction

The mid-1980s marked the beginning of an ambitious plan to regenerate Belfast, starting with the area around the river Lagan. Once the industrial heart of the city, the river and its surrounds had been more or less abandoned as dirty and dilapidated. Because of the Troubles, Belfast itself had a serious image problem, with most of the world regarding it merely as a battle-scarred wasteland.

During this time, in 1986, Chris opened his photographic studio in a Victorian warehouse in the old linen quarter behind the City Hall. Jill joined the studio in 1989, and photographing the positive side of the city we loved became our driving passion. Since the ceasefires in the 1990s, we have found that more and more people are sharing this passion, looking with renewed pride at a city whose architecture had almost been forgotten during the conflict. Gradually, buildings that previously would have been torn down were being saved and given imaginative facelifts. As commerce began to hum again, citizens enjoyed a new kind of nightlife in the European-style cafés and smart bars which now flourish alongside the traditional Victorian pubs.

Our work takes us to every corner of Belfast, and we are always grateful to the people we meet for their characteristic spirit and the generosity of their welcome. The atmosphere in a pub or restaurant can be momentarily altered by the arrival of a photographer, but we always strive to blend into the background as far as possible. Sitting down for a pint before a shoot is sometimes a requirement (more than two pints is a disaster!). Out of doors, the weather is paramount for the creation of exciting photographs, and knowing how to utilise it is part of the landscape photographer's skill. Being prepared to wait is the key. In Ireland, a typical day is always a changeable one, and alternating showers and sunshine offer a great opportunity to catch dramatic skies and light. Whether you are from Belfast or not, we hope these pictures inspire you to see the city from a different perspective and that you will enjoy looking at them as much as we have enjoyed taking them.

We would like to thank the following people. First of all, our families, who deserve special credit for sometimes having to model at short notice, or having to postpone an engagement because the sun has come out after four hours of waiting. Our pilot and friend Jim Mitchell for his enthusiasm in always trying to fly over city landmarks as low as possible above the regulation height. The Belfast Visitor and Convention Bureau, the Belfast Harbour Commissioners, Laganside Corporation, and the architects who commissioned many of the images that make up this book. All the team at Christopher Hill Photographic including Nicola McGimpsey, Nick Patterson and especially Bob Malone, who worked night and day to digitise these images for publication. Finally, special thanks to Wendy and Anne at Blackstaff Press who had the vision to commission a second photographic book on Belfast from ourselves.

Chris Hill and Jill Jennings
Belfast, October 2001

All these images, and more, can be viewed on our website www.scenicireland.com, or you can phone us on +44 (0)28 9024 5038.

Big Fish at Donegall Quay, a ceramic sculpture created by John Kindness to mark the Millennium, contains a time capsule of Belfast life in 1999.

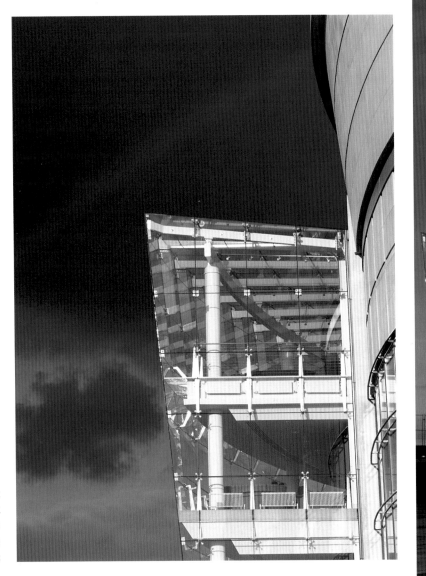

Belfast's magnificent
Waterfront Hall at
Lanyon Place, home to
concerts, conferences
and exhibitions

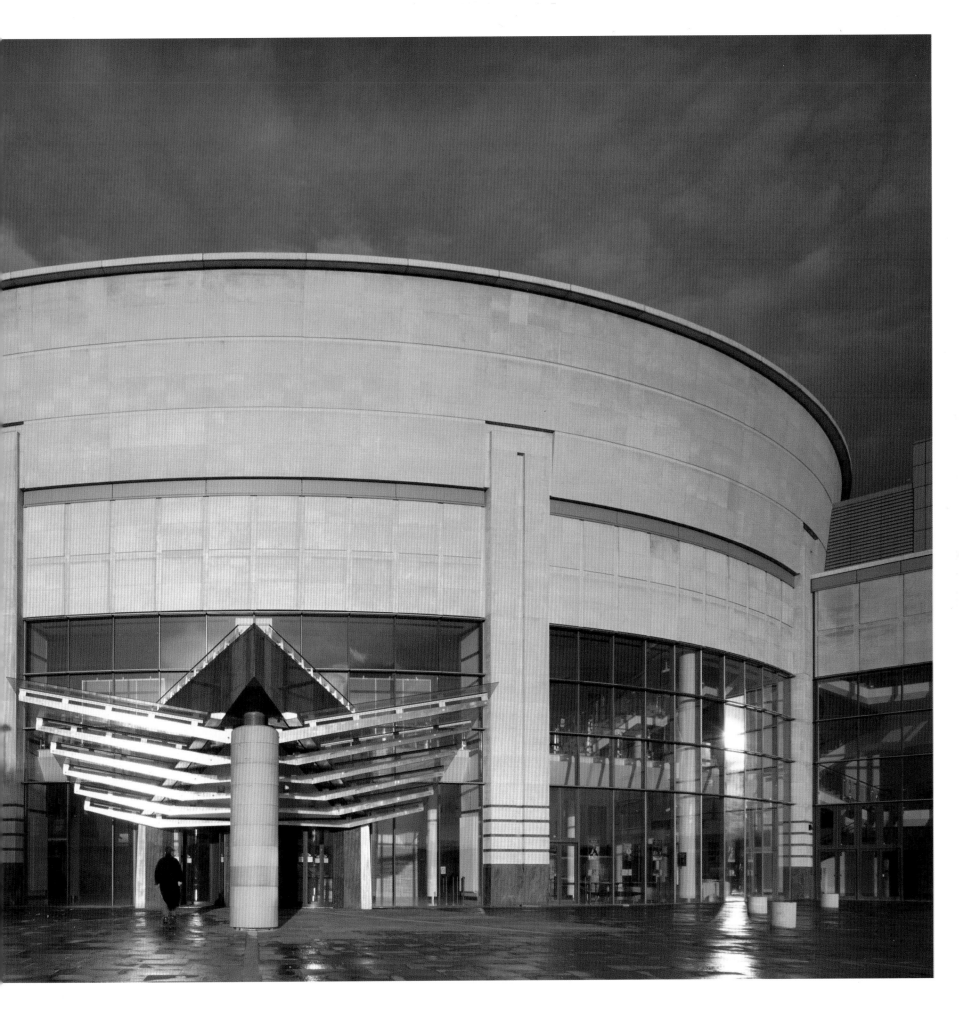

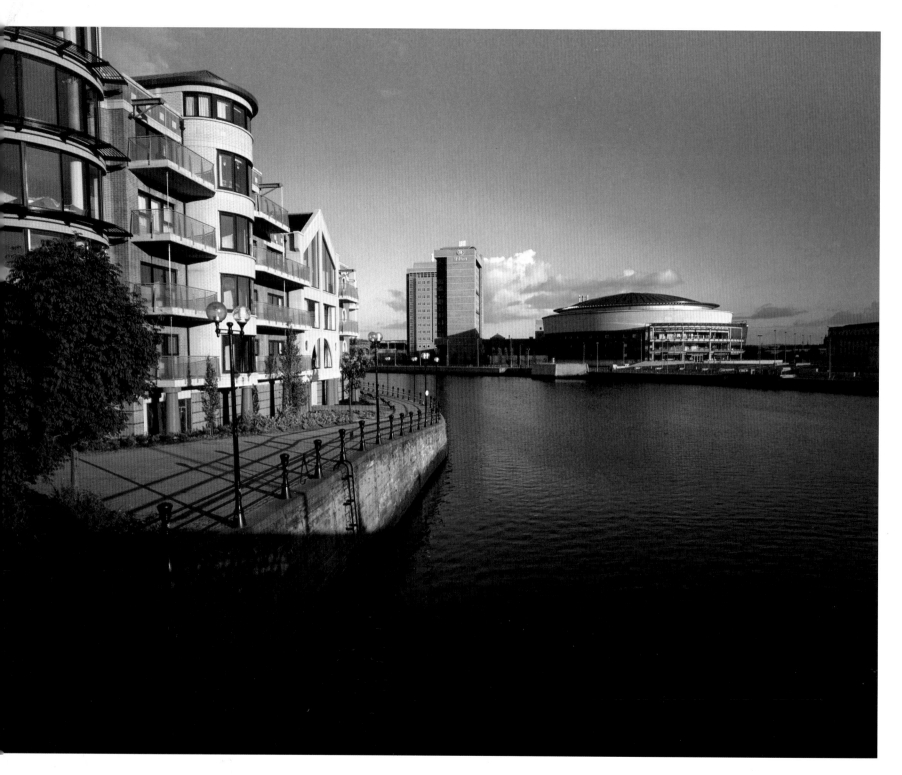

Regeneration on the river Lagan

Above: The view from the Queen's Bridge, with Gregg's Quay apartments on the left and, across the river, the BT tower, the Hilton Hotel and the Waterfront Hall

Opposite (from the left): Apartments at May's Meadows, the Edge bar and restaurant, the Waterfront Plaza office building (occupied by PriceWaterhouseCooper), the Hilton Hotel and the Waterfront Hall

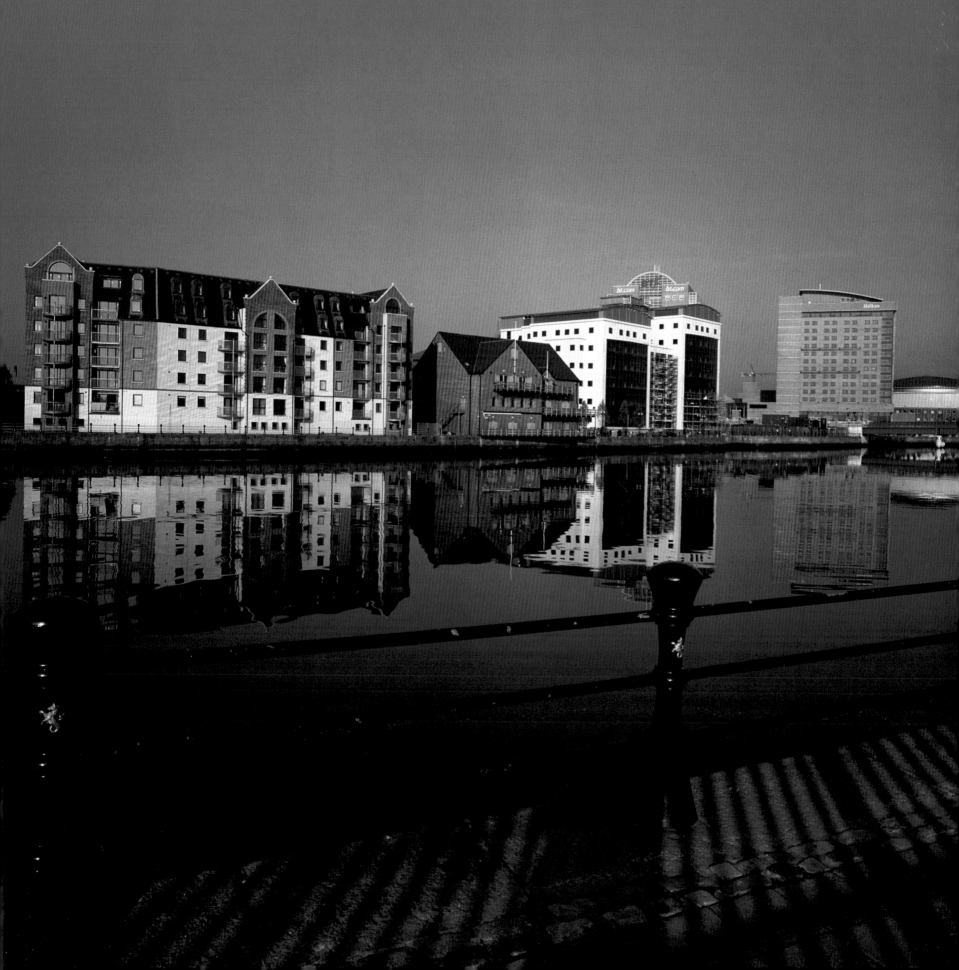

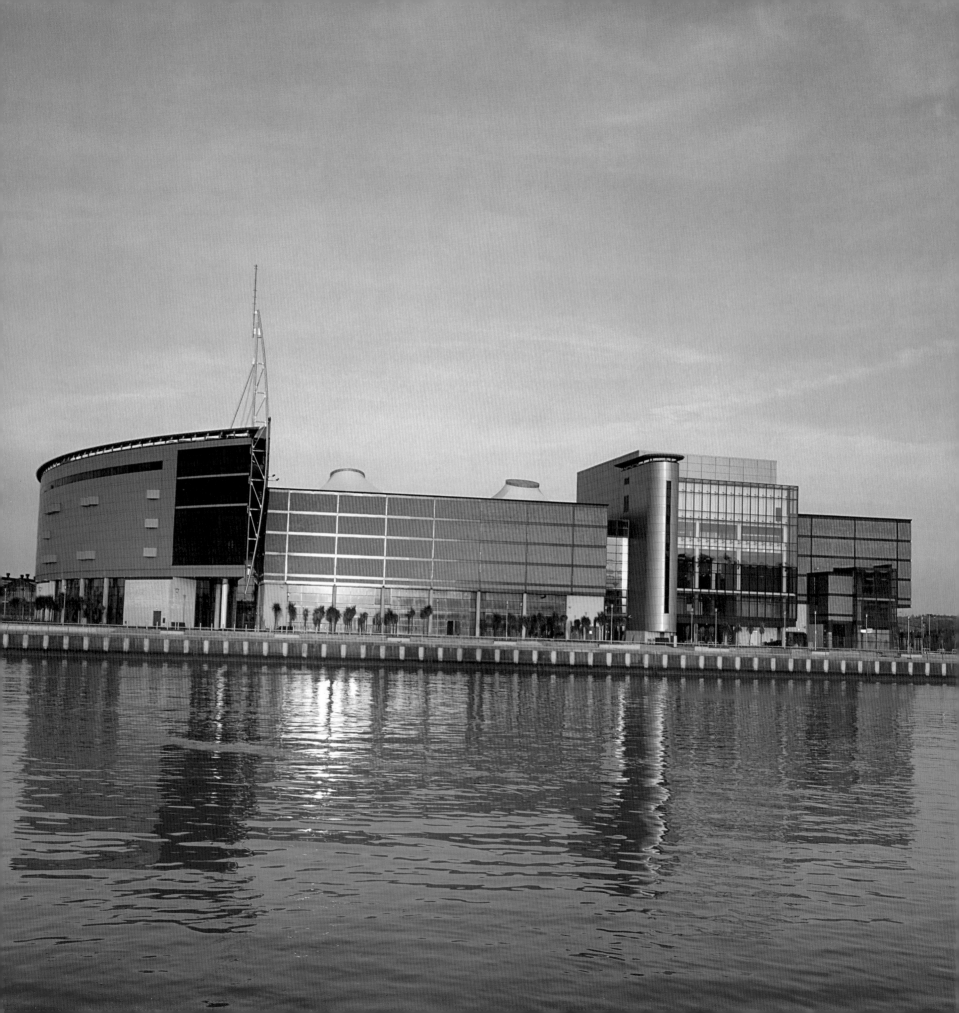

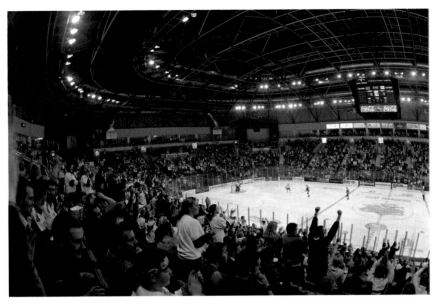

Opposite and below: Odyssey, the new entertainment complex at Queen's Quay, includes a 10,000-seater arena, W5 (an interactive science discovery centre), an IMAX cinema, a 12-screen multiplex and a range of restaurants, bars and leisure facilities.

Left: The Odyssey Arena, home of the Belfast Giants ice-hockey team

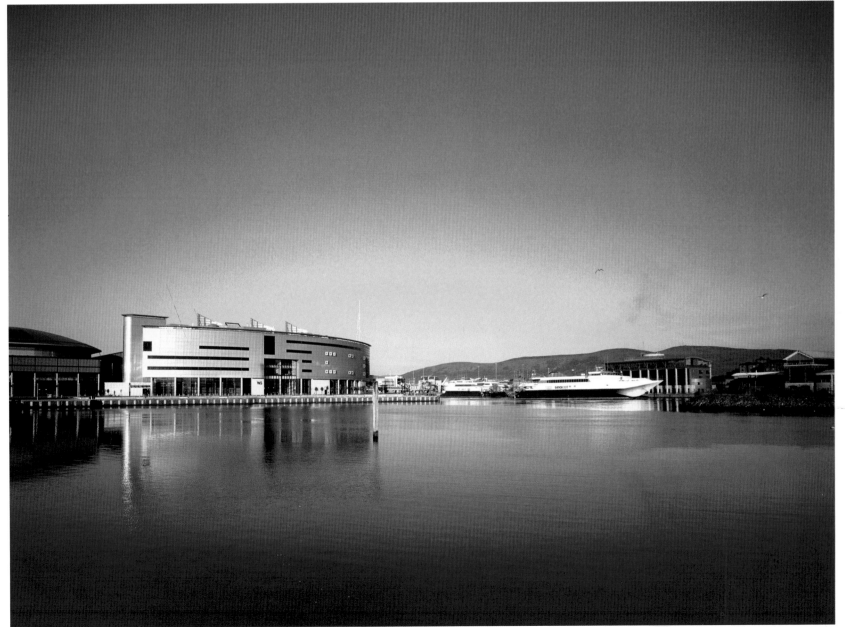

New development on the east Belfast side of the Lagan

To the left of the Queen's Bridge: the Odyssey Complex, Quaygate House and Harland and Wolff's famous shipyard cranes, Samson and Goliath. Between the Queen's Bridge and the railway bridge at the far right are the apartment buildings at Gregg's Quay and Lagan View. Parliament Building at Stormont can be seen on the hill behind the Dunloe Ewart building.

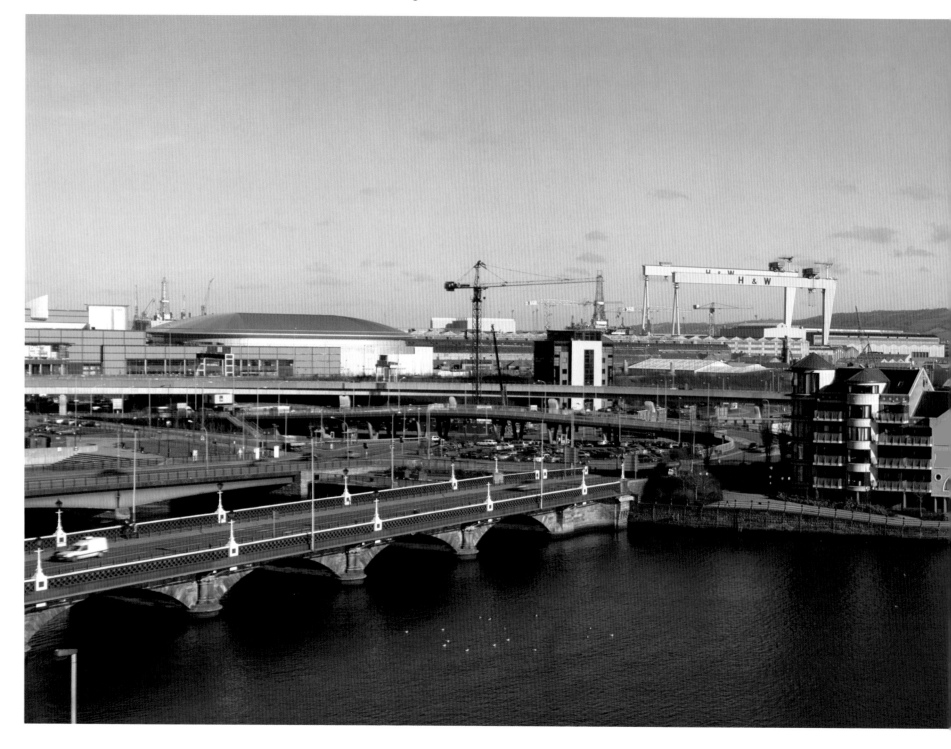

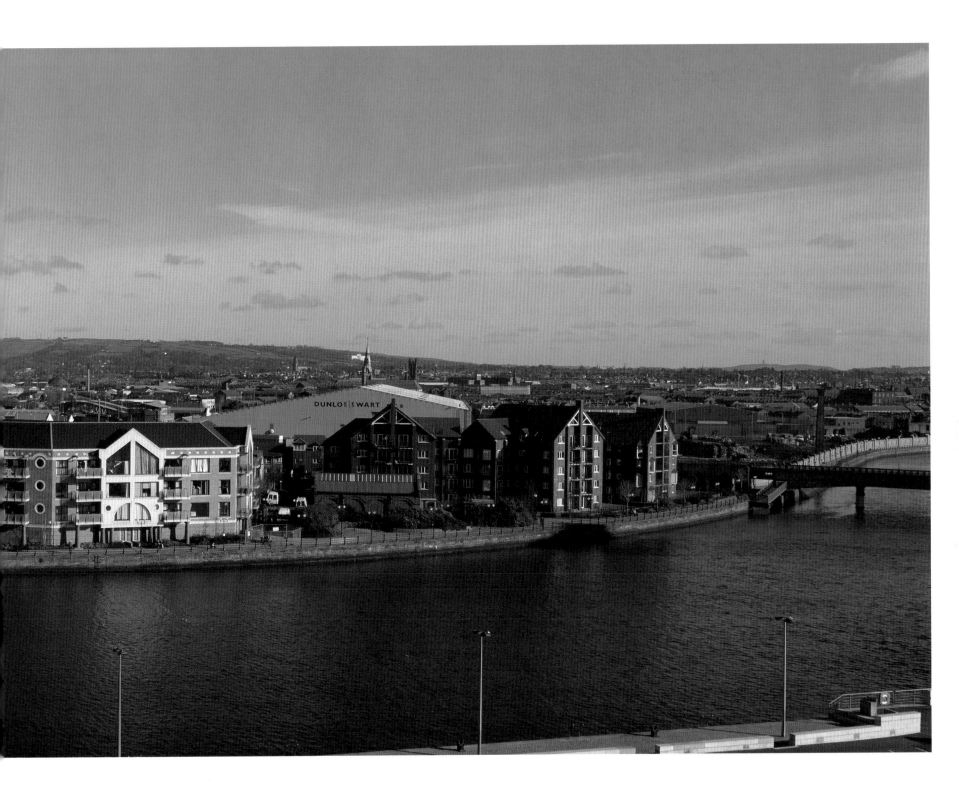

The Victorian exuberance of the Queen's Bridge provides a striking vantage point for the modern architecture of Belfast's Laganside development. *From left*: the Hilton Hotel with its close neighbour, the BT Tower; the Waterfront Hall; and the Royal Courts of Justice.

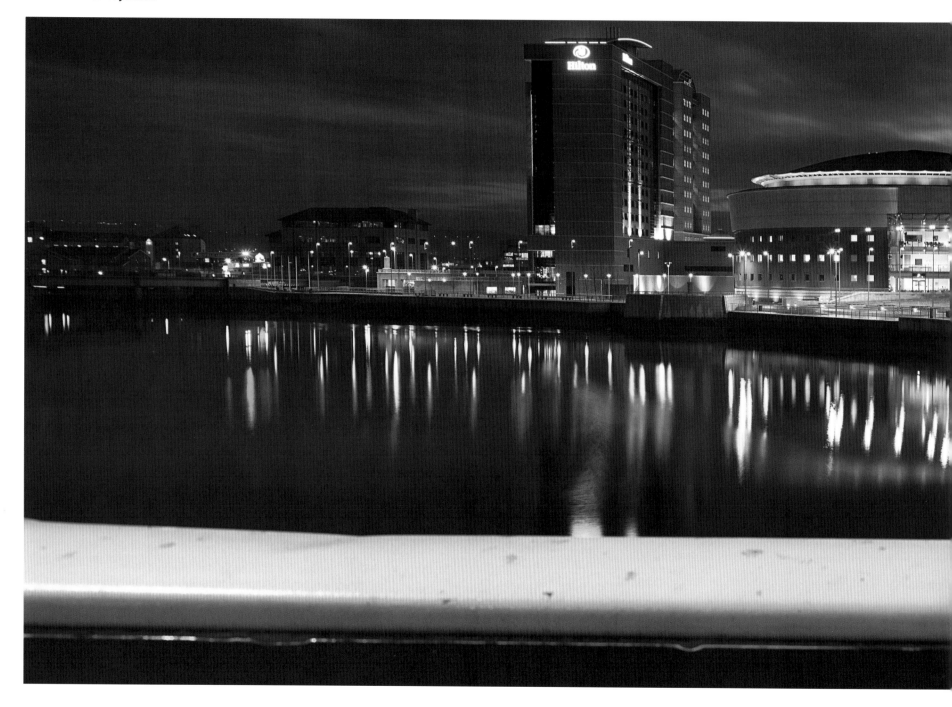

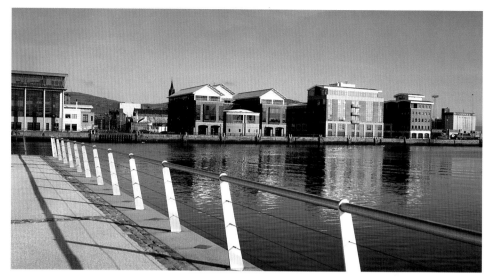

Opposite: Belfast Harbour Office, Corporation Square

Right: Recent office development at Clarendon Dock

Below: Clarendon Building, once the office of the Belfast Harbour Master, now houses the Laganside Corporation.

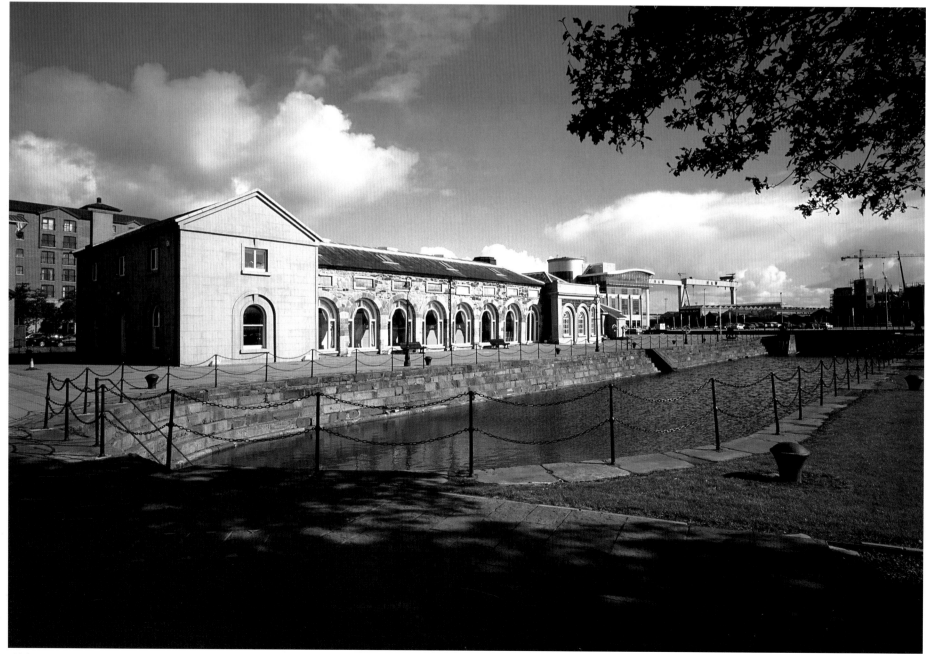

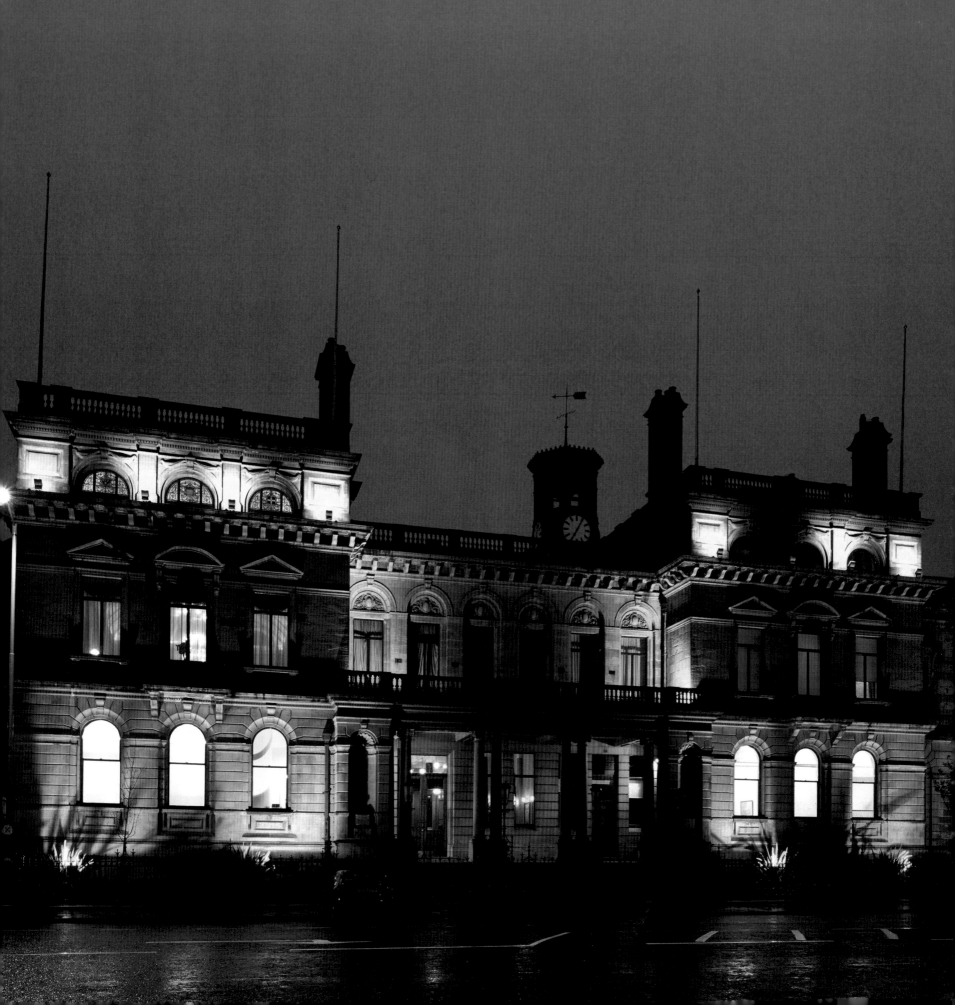

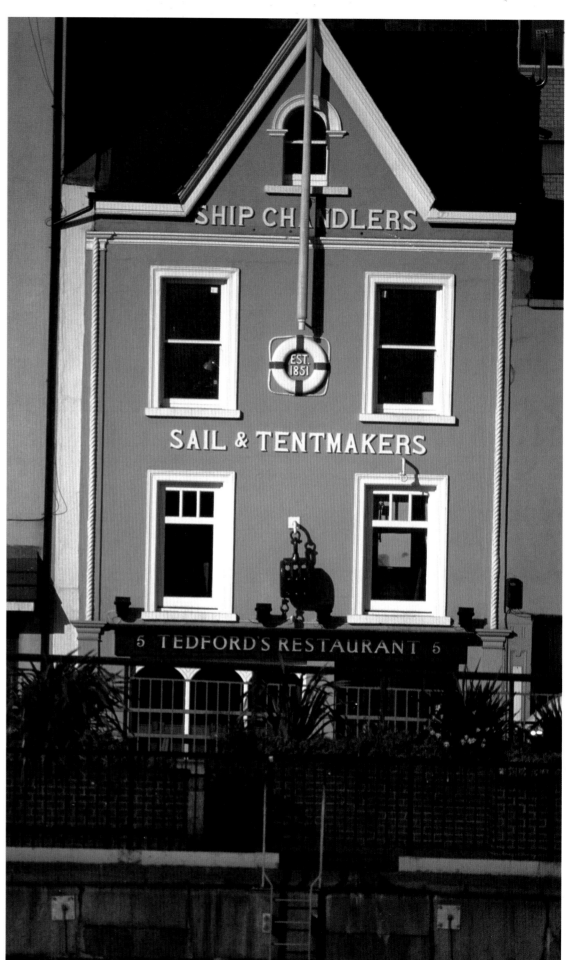

Above and right: The landmark Tedford's Chandlery on Donegall Quay is now a welcoming restaurant.

Opposite: The view from the top floor of Donegall Quay high-rise carpark includes the Lagan Lookout and Weir, the M3 Bridge and, in the distance, the cranes of the Harland and Wolff shipyard.

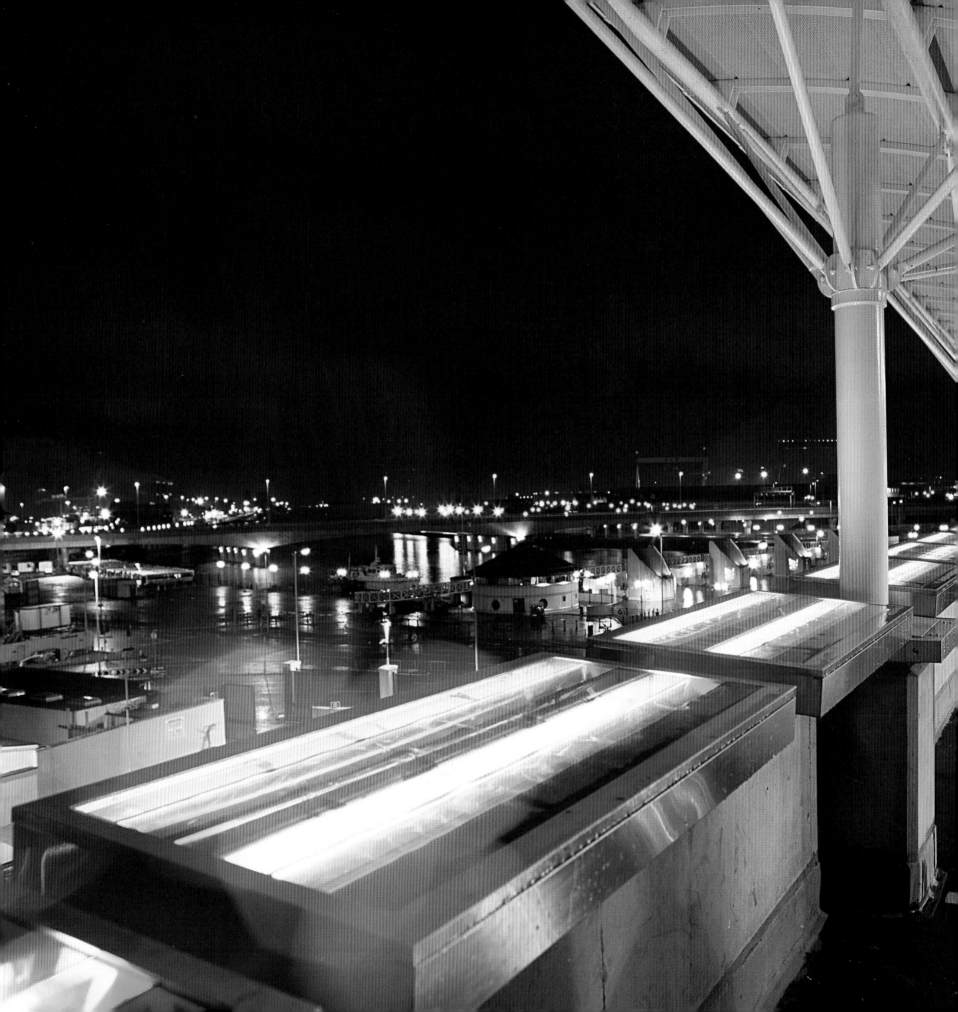

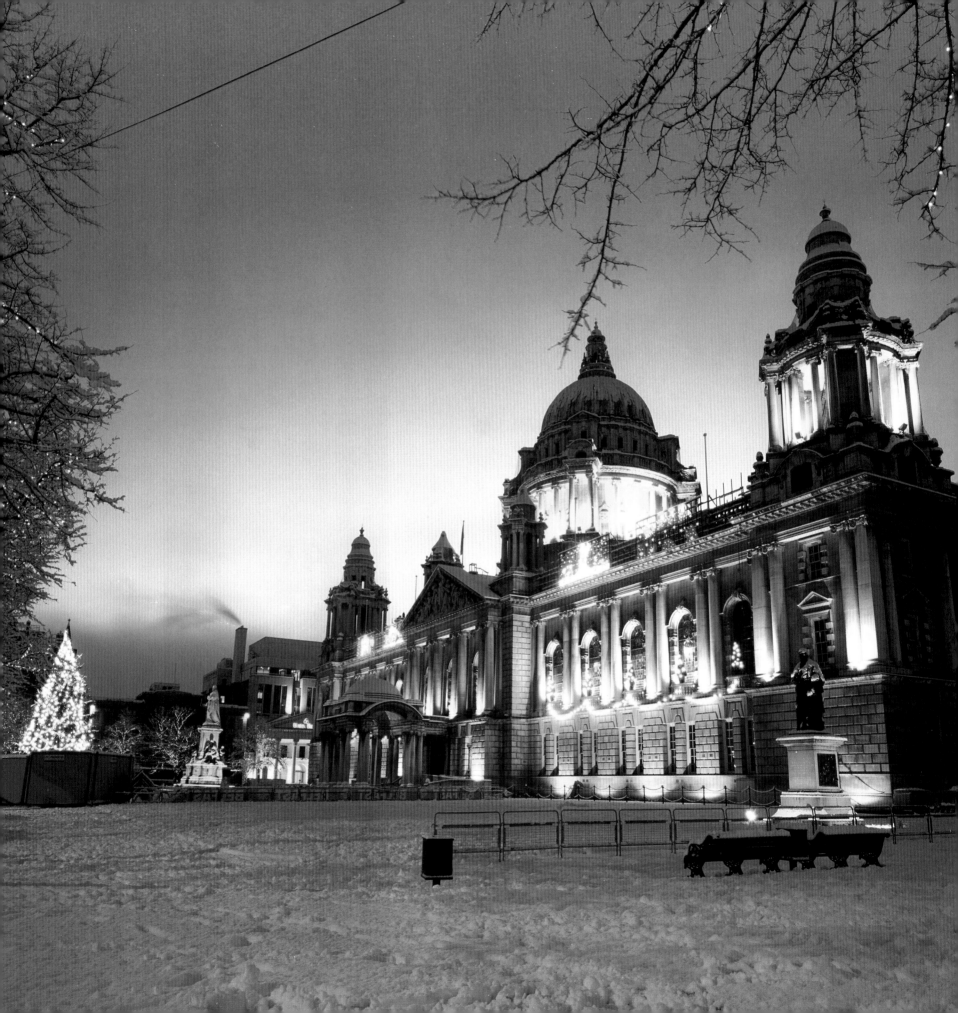

Opposite: Belfast City Hall at Christmastime

Left: The Dufferin and Ava Memorial, Donegall Square West

Below: Office workers enjoy a sunny lunchtime break in the City Hall grounds while Queen Victoria surveys the shoppers in Donegall Place.

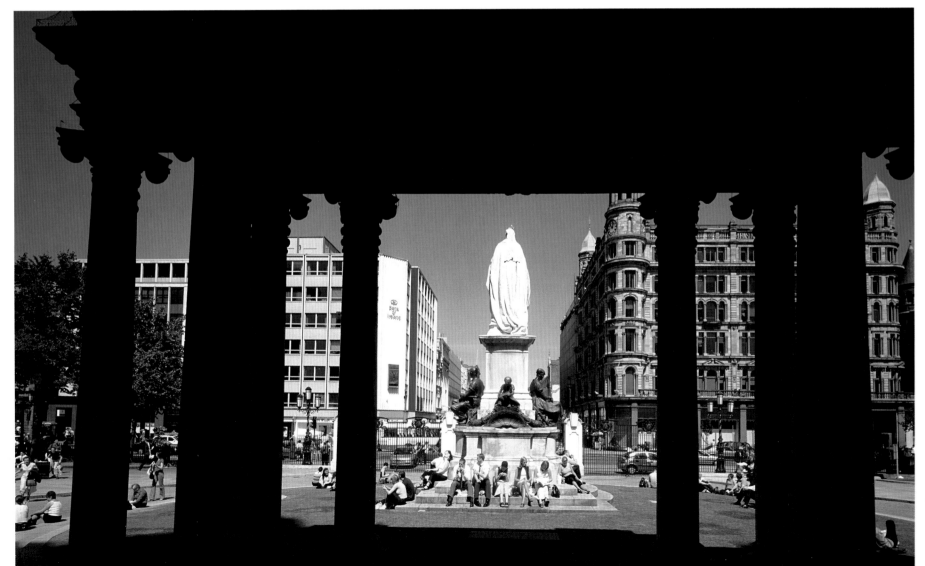

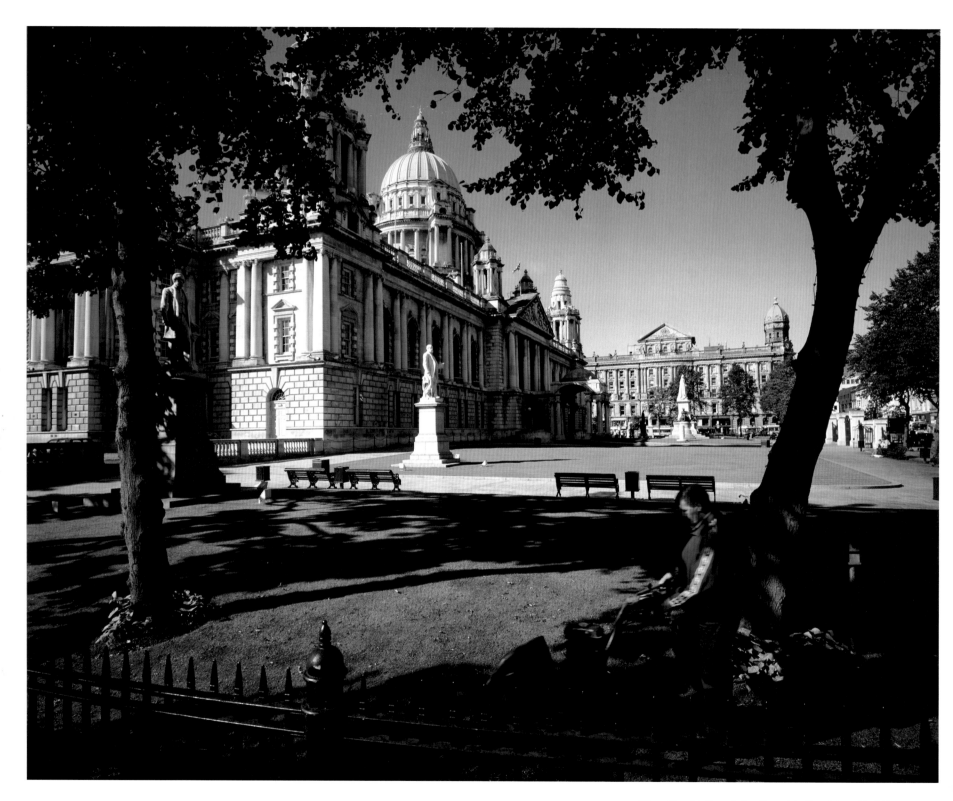

The City Hall and the Scottish Provident Building
from Donegall Square East

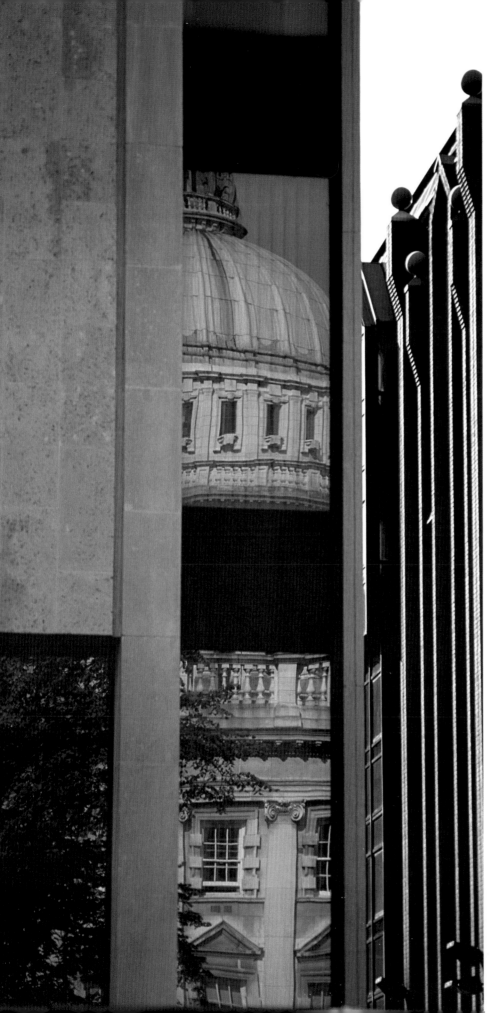

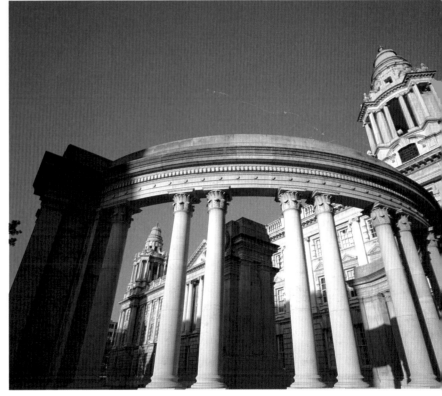

Left: History and modernity make an interesting mix at the entrance to Wellington Street

Above: Garden of Remembrance, City Hall

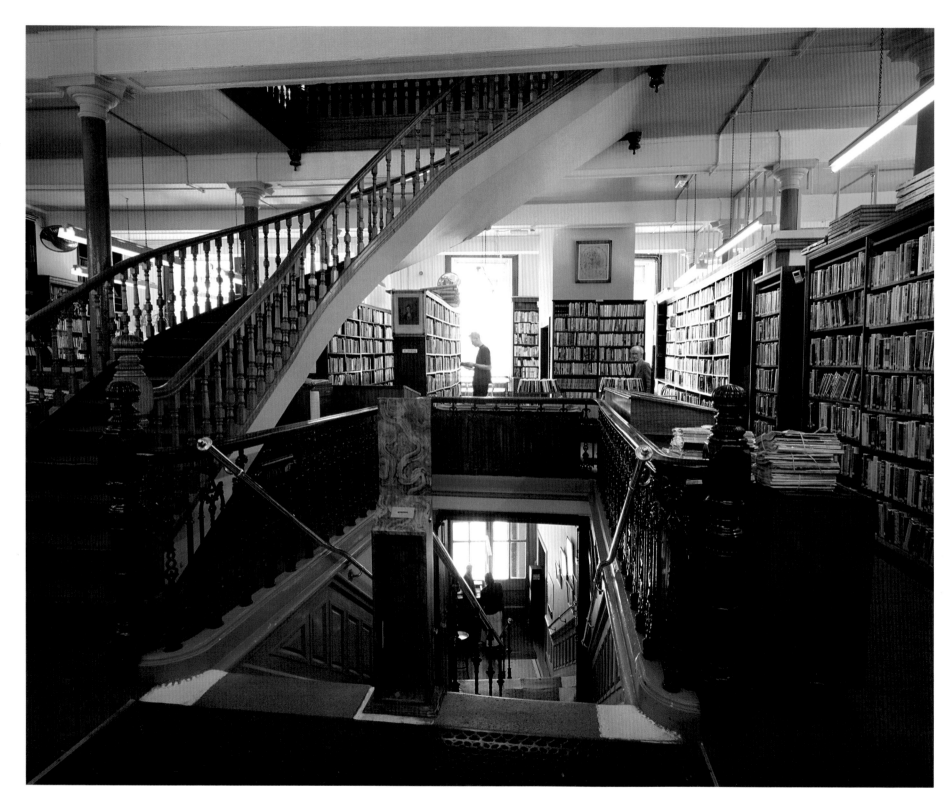

The deep peace of the historic
Linen Hall Library is just a step away from
the clamorous pavements of the city centre.

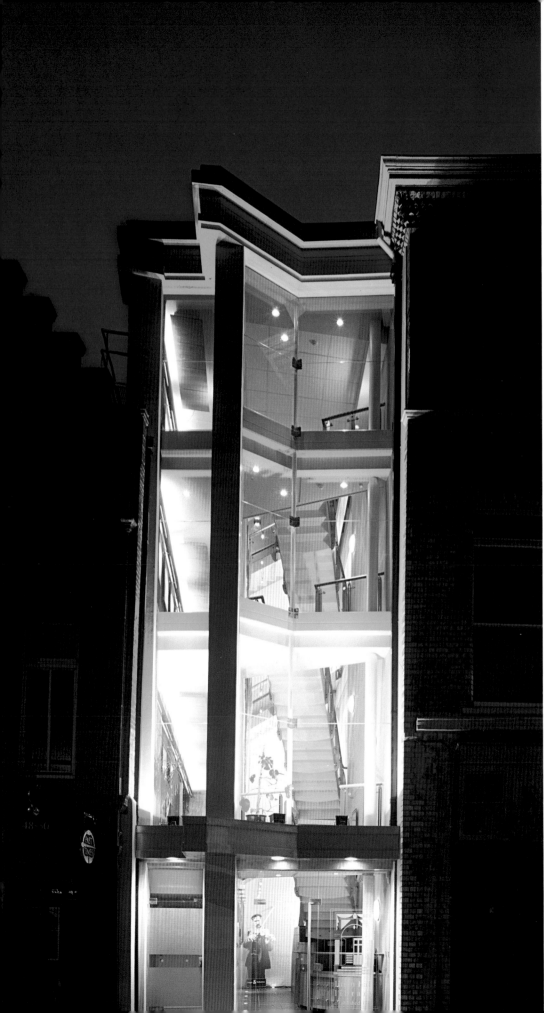

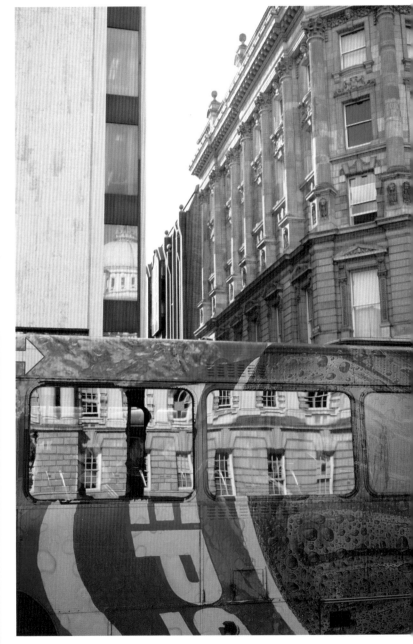

Above: Past and present converge in reflections in Donegall Square West

Left: The new Fountain Street entrance to the extended Linen Hall Library

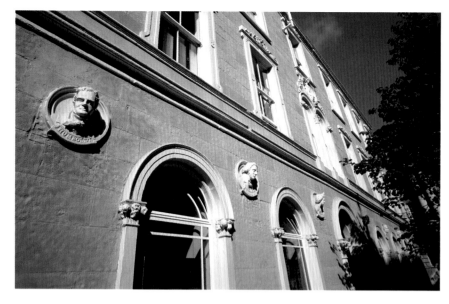

Right: Architectural detail in Donegall Square South. Once a post office, this building now houses 10 Square, a fashionable new restaurant and hotel complex.

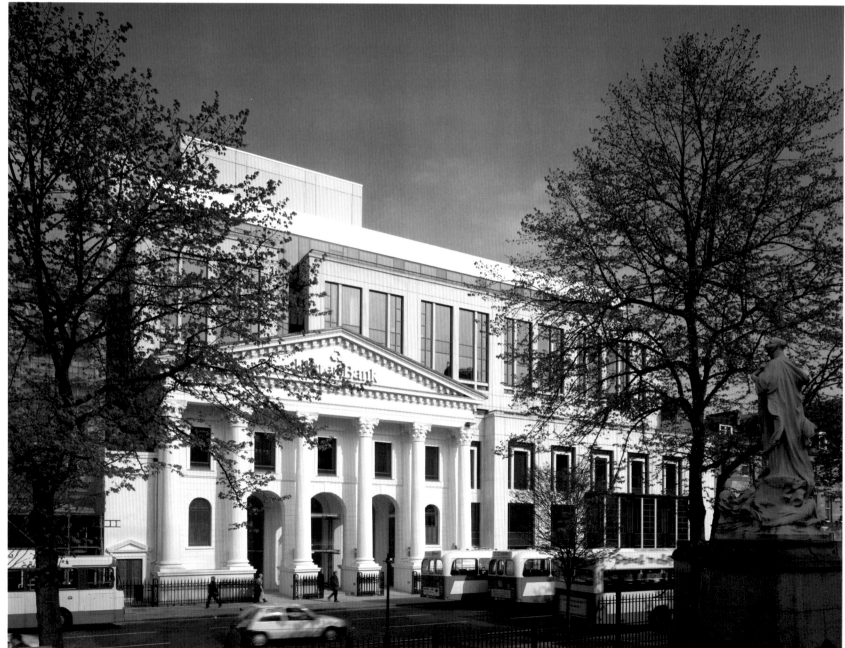

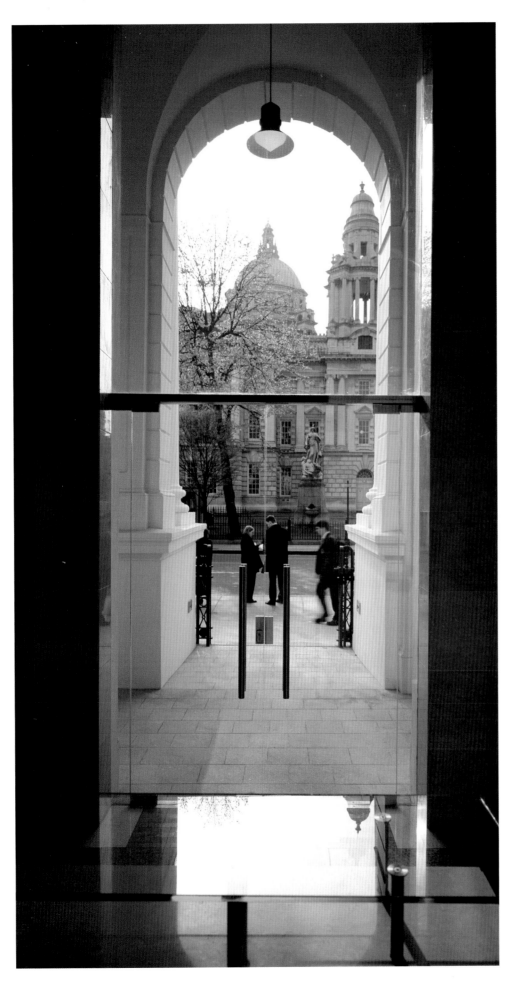

Opposite and left: The Ulster Bank's new headquarters in Donegall Square East, built around the classical façade of a vacated Methodist church.

The Apartment café and bar, Donegall Square West 27

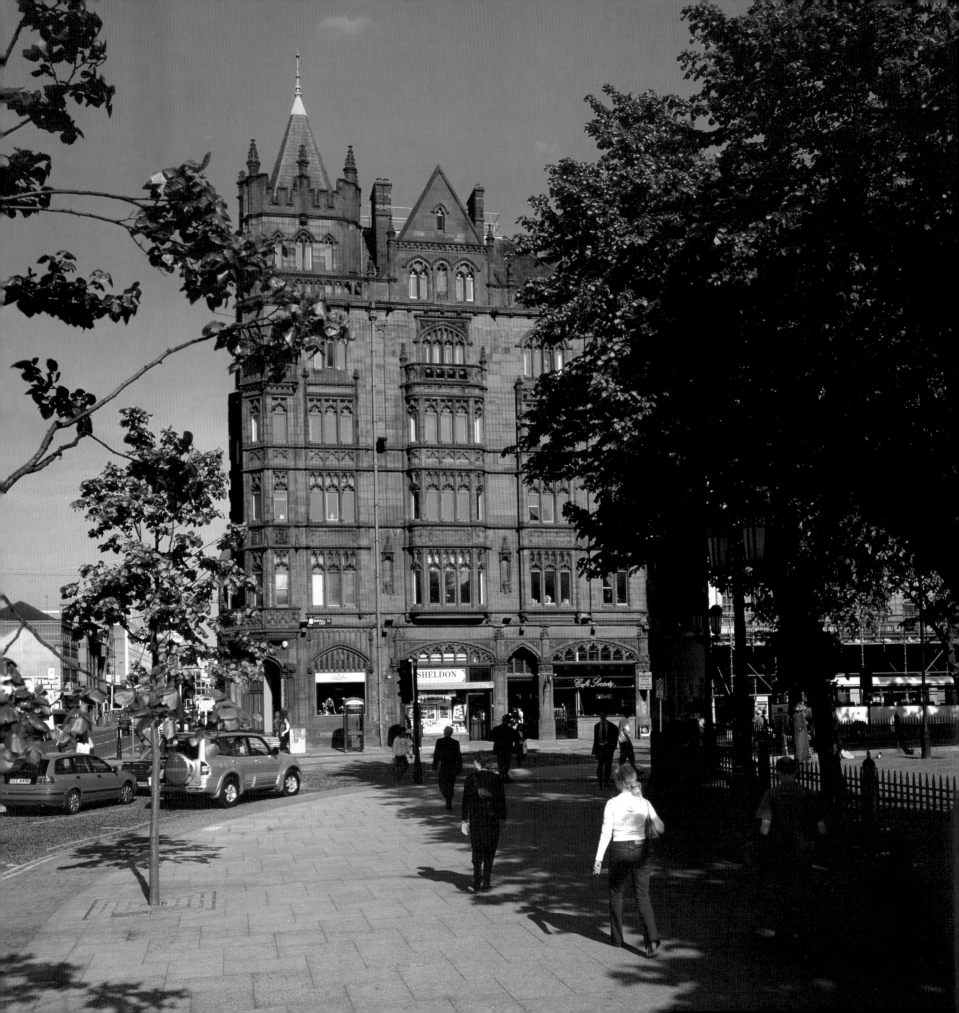

Opposite: The Pearl Assurance Building, Donegall Square East

This page: The Grand Opera House, designed by the famous theatre architect Frank Matcham and opened in 1895.

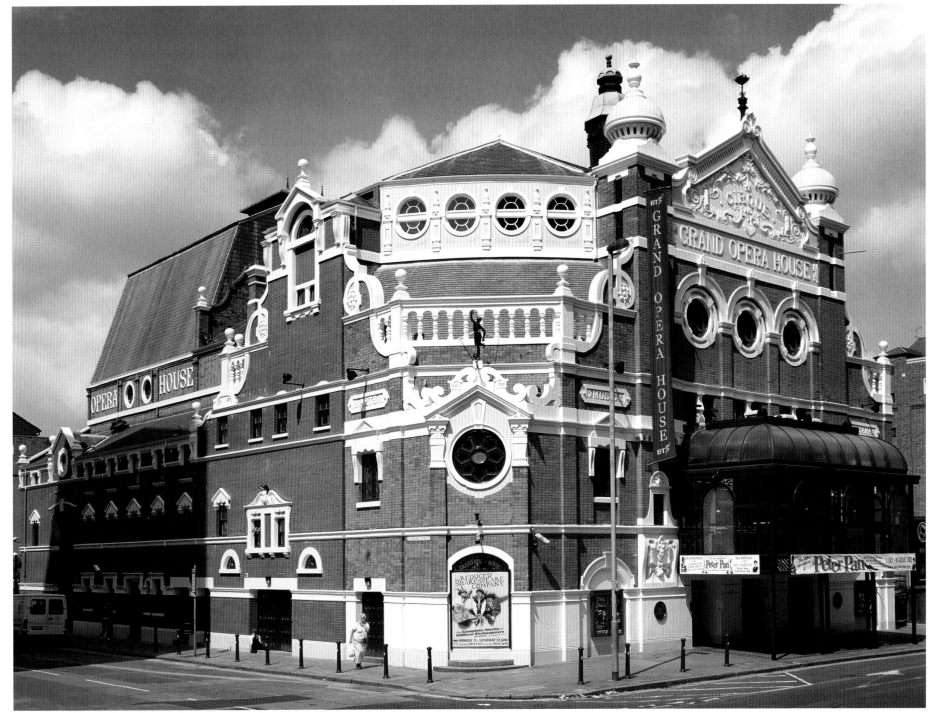

Owned by the National Trust for
Northern Ireland, the Crown Bar in
Great Victoria Street is a magnet for
citizens and tourists alike.

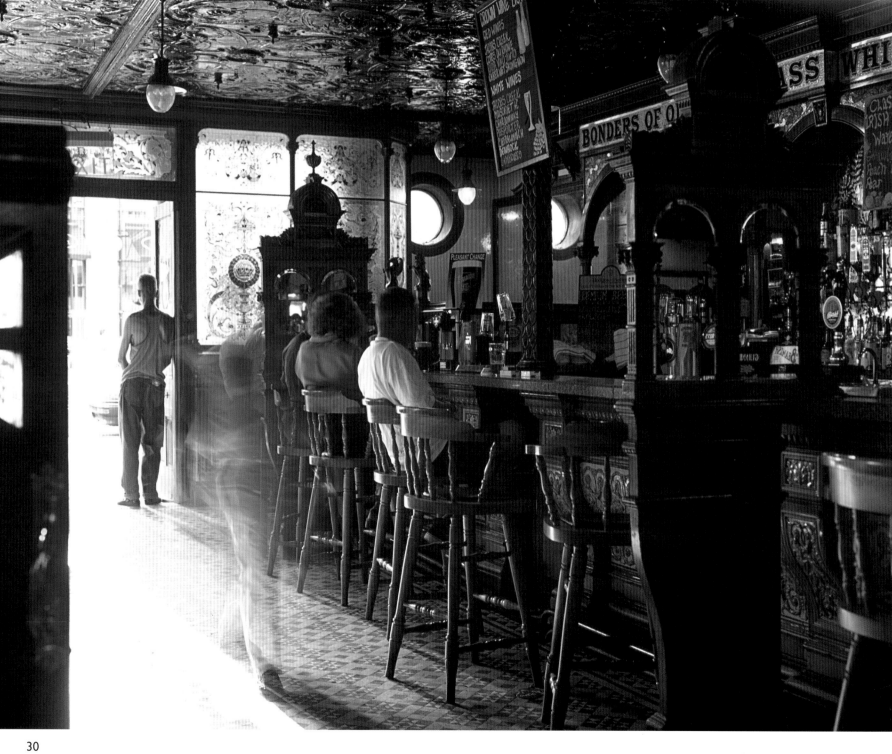

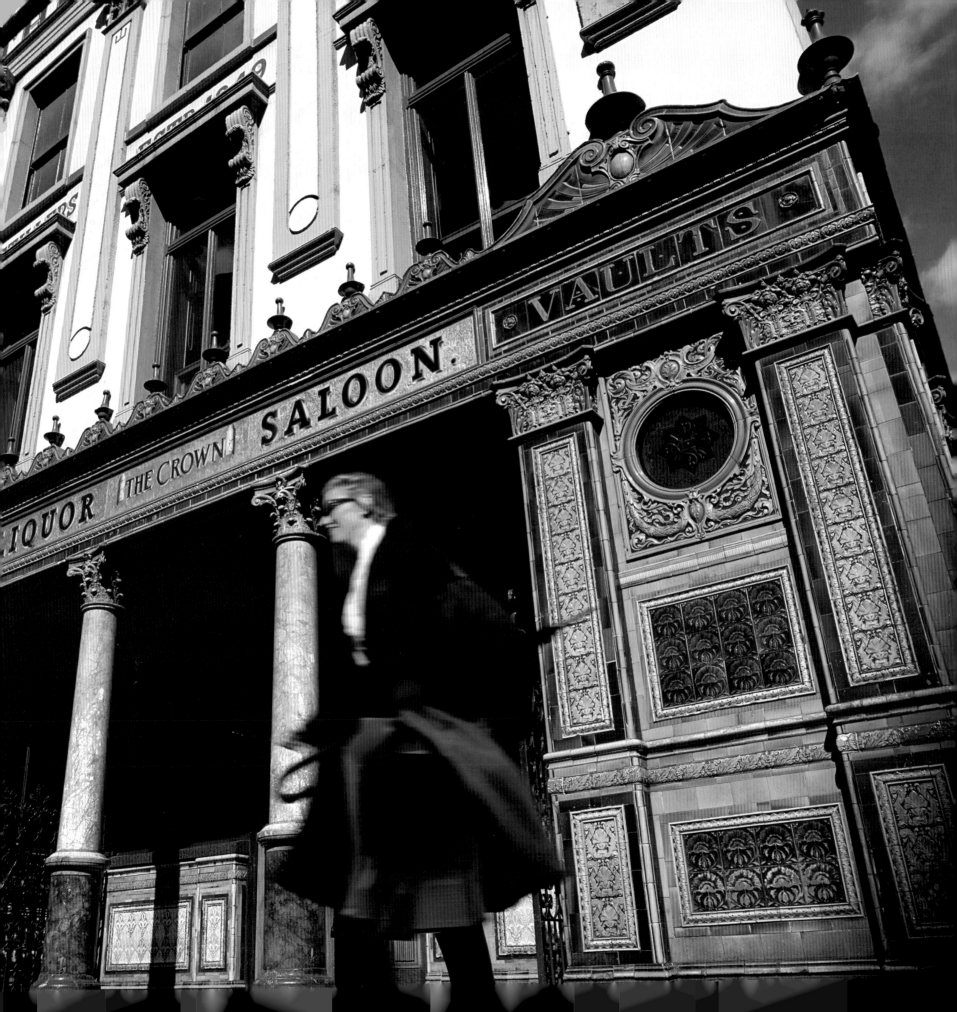

Right and opposite: Generations of Belfast children learned to sink or swim in the municipal pool in Ormeau Avenue. Now, as the Ormeau Baths Gallery, it provides a stylish space for innovative works of art.

Below: The Ulster Hall in Bedford Street has witnessed stormy political meetings and boxing tournaments as well as popular and classical music concerts.

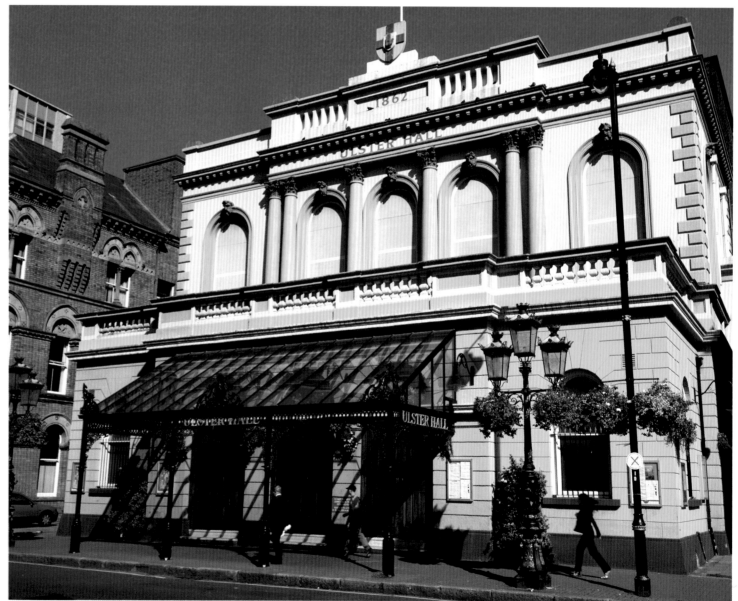

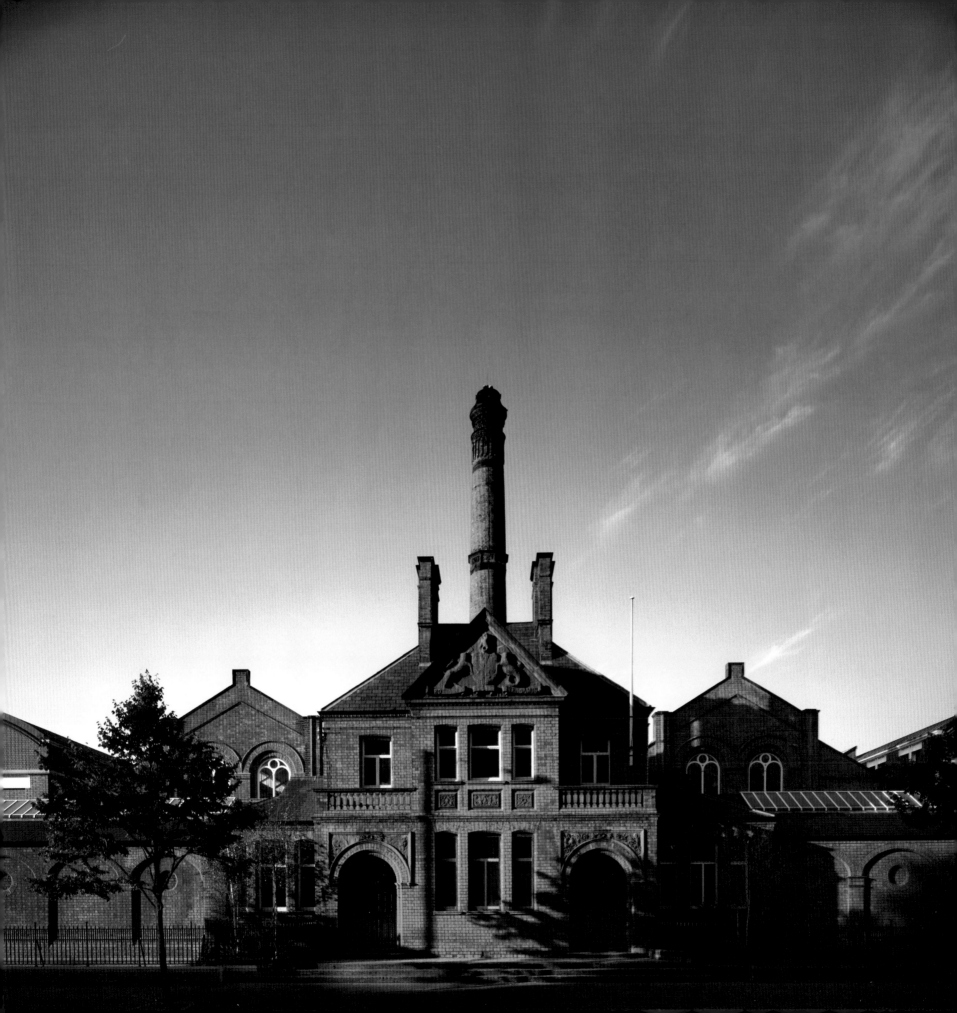

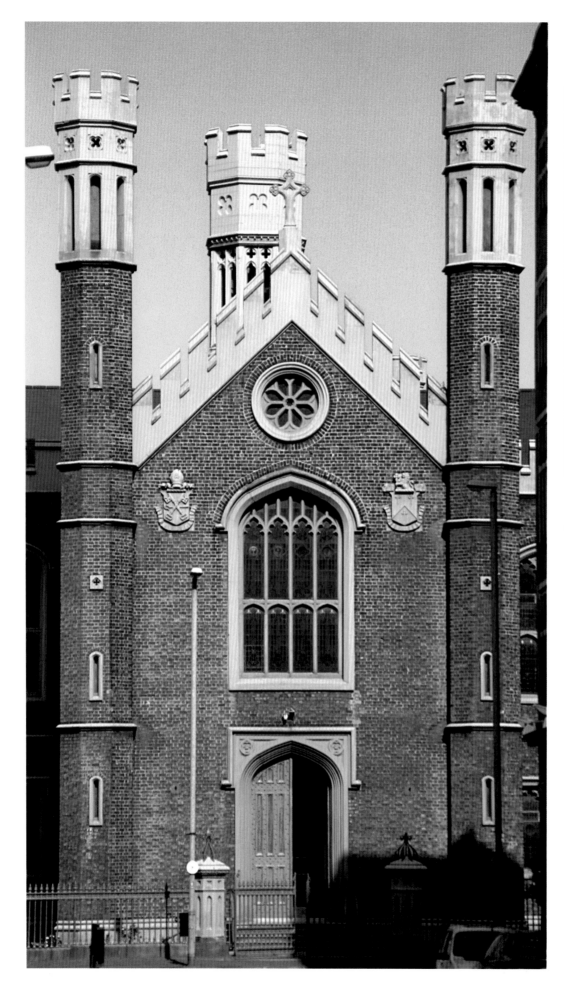

Left: St Malachy's Church, Alfred Street

Above: A Georgian house in Hamilton Street in the Cromac area

Opposite: The popular weekly market in the newly refurbished St George's Market

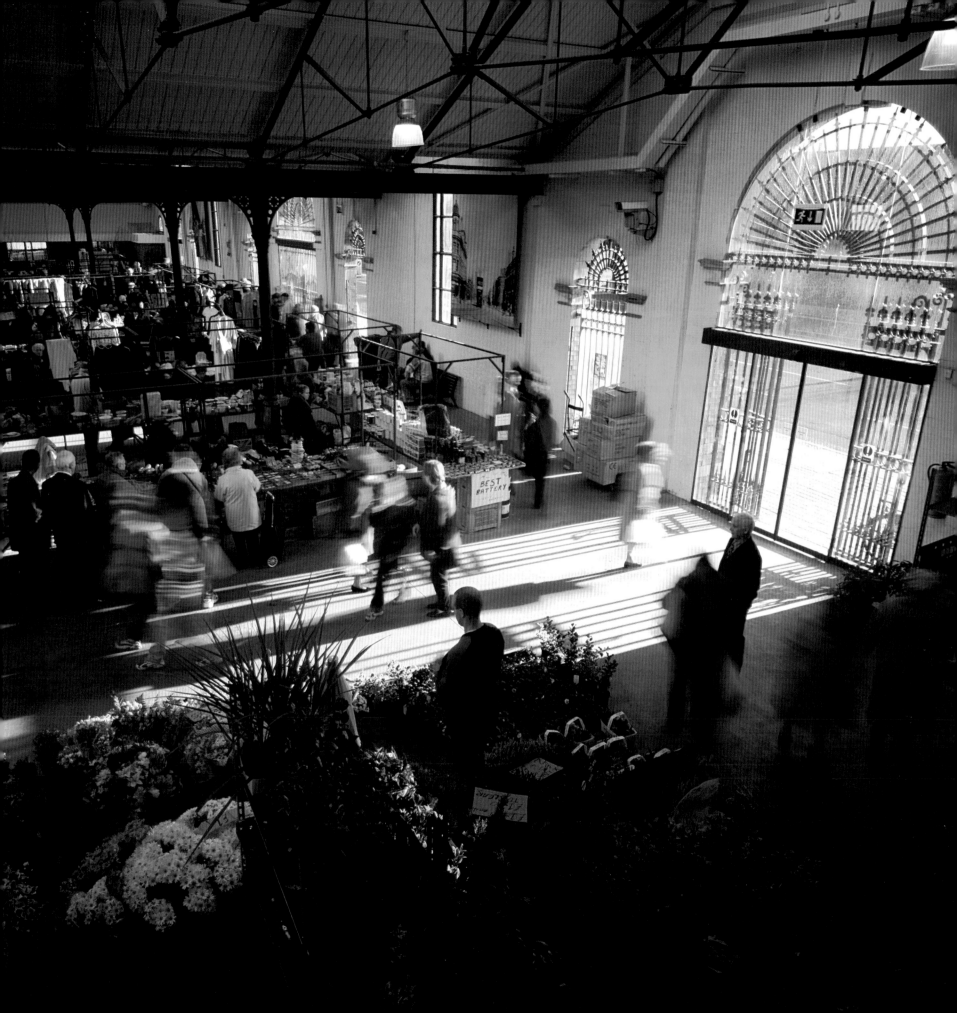

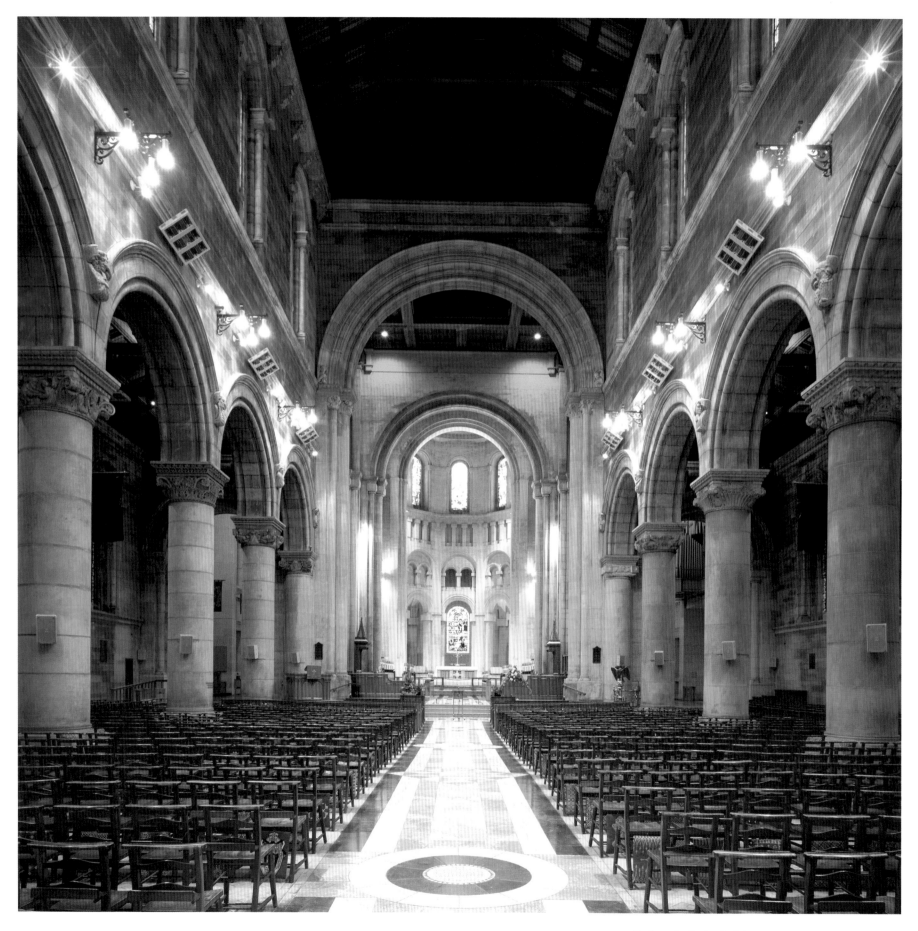

St Anne's Cathedral, Lower Donegall Street

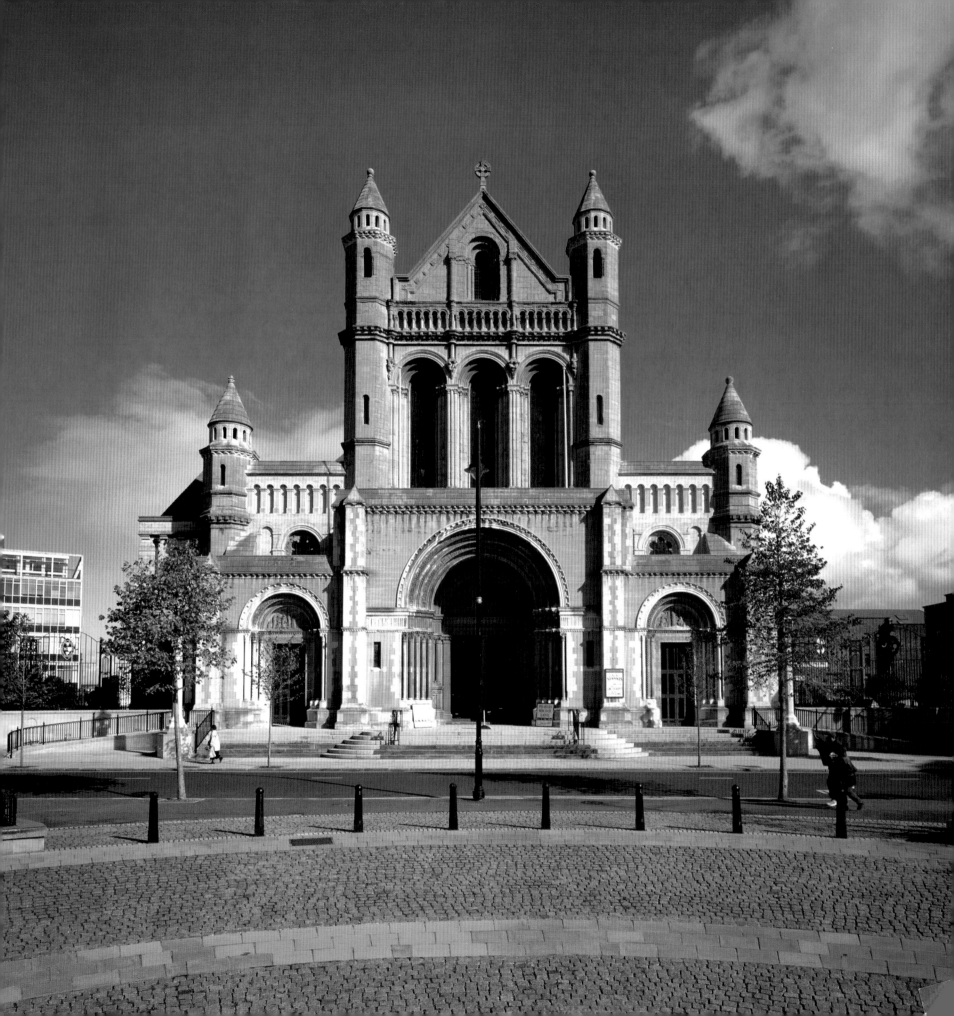

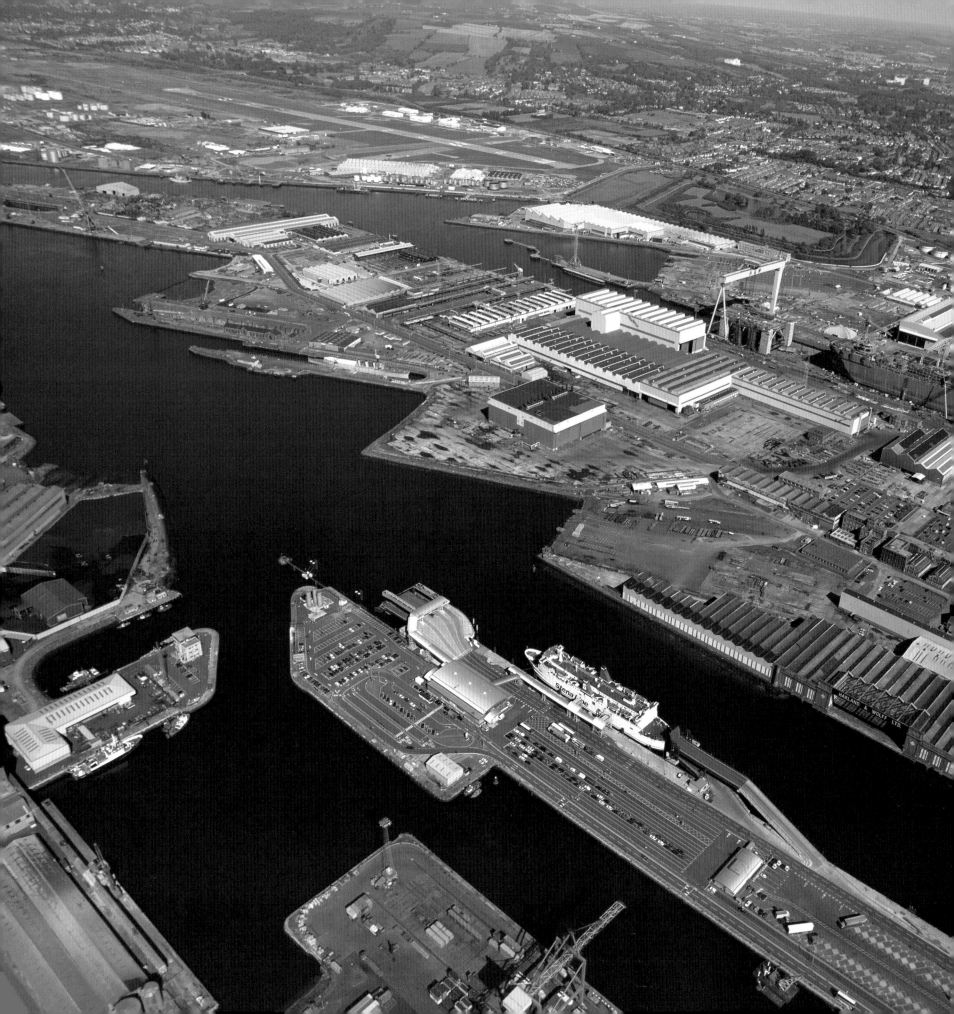

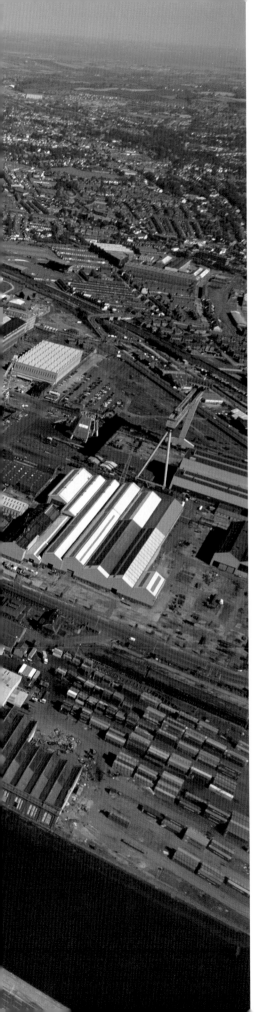

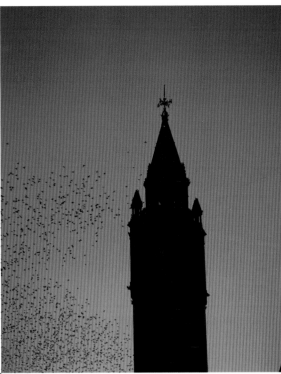

Opposite: Belfast's extensive docks. In the foreground, a Stena Line ferry prepares for the return trip across the Irish Sea to Stranraer. The open space just above the ferry is where the *Titanic* and her sister ships were built in the early part of the twentieth century by Harland and Wolff, whose shipyard dominates the middle section of this photograph.
Towards the top left the runways of Belfast City Airport can also be seen.

Above: One of the great sights of Belfast: thousands of starlings flock around the Albert Clock near the docks.

Left: The famous cranes of Samson and Goliath tower over the gates of the Harland and Wolff shipyard.

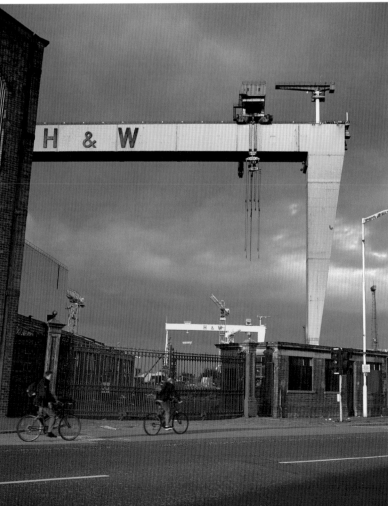

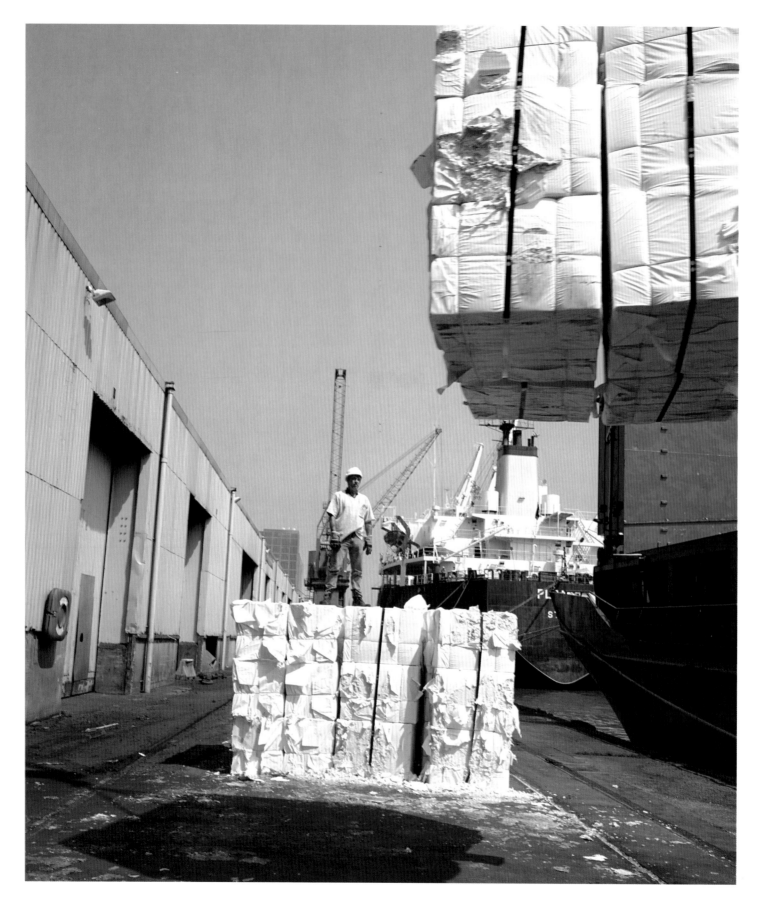

On the waterfront: hard graft at Belfast docks

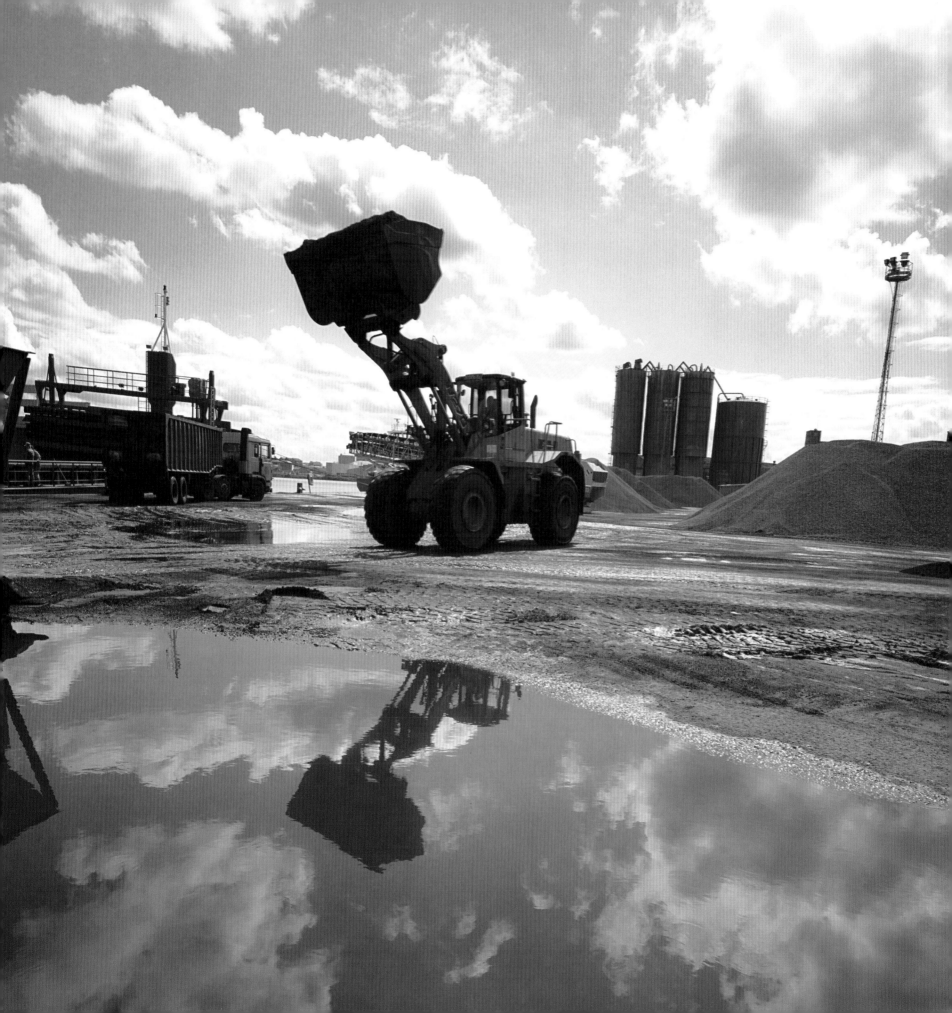

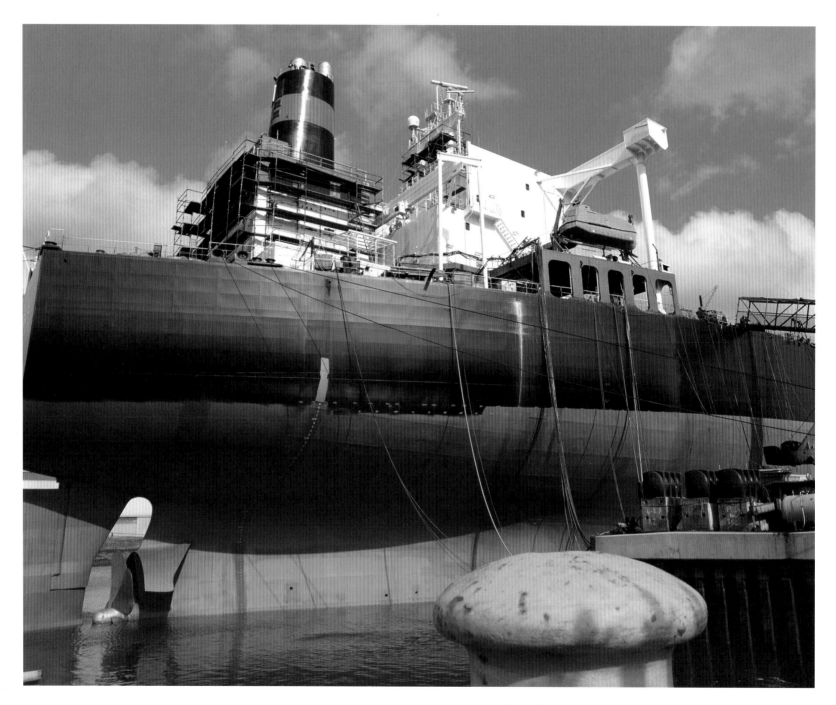

Above: Fitting out an oil vessel at Harland and Wolff shipyard

Opposite: In recent years, cruise liners like the vast *Deutschland* have begun to include Belfast in their itineraries again.

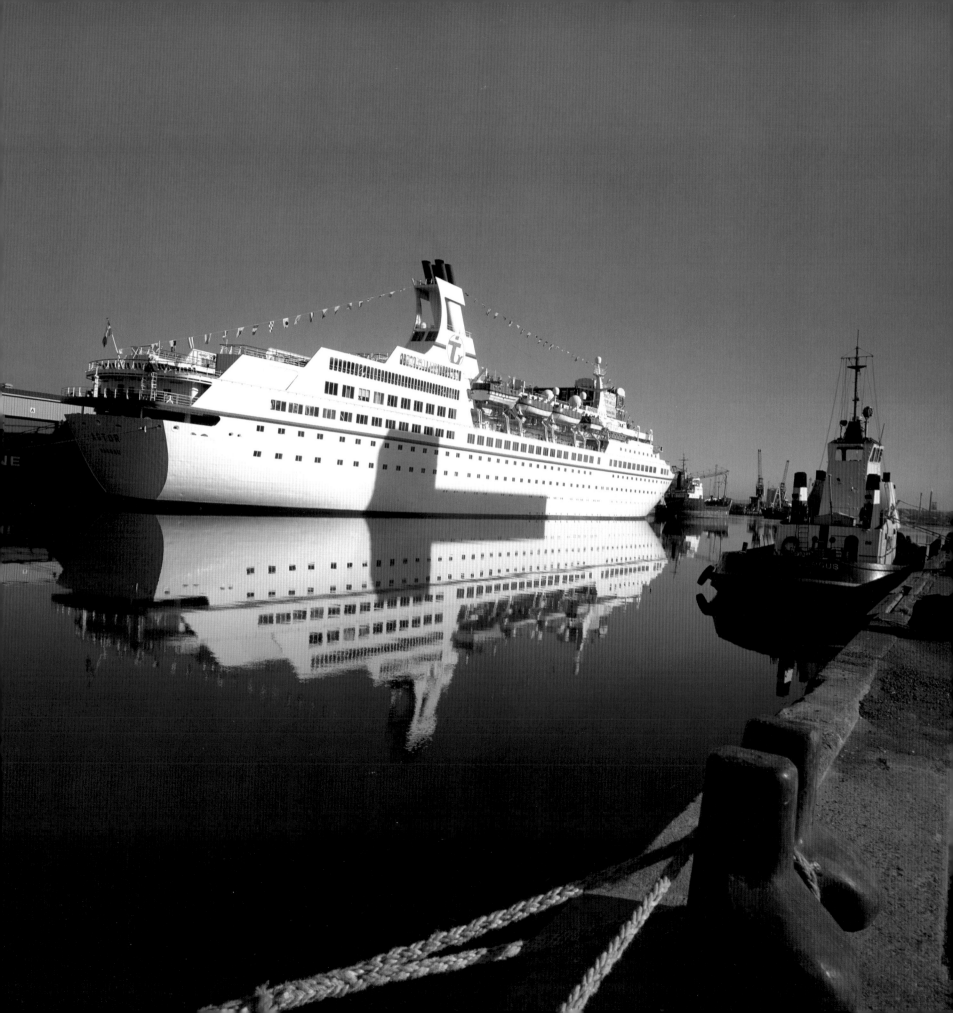

Late night working at Harland and Wolff shipyard on (*left*) an oil vessel and (*right*) an oil rig

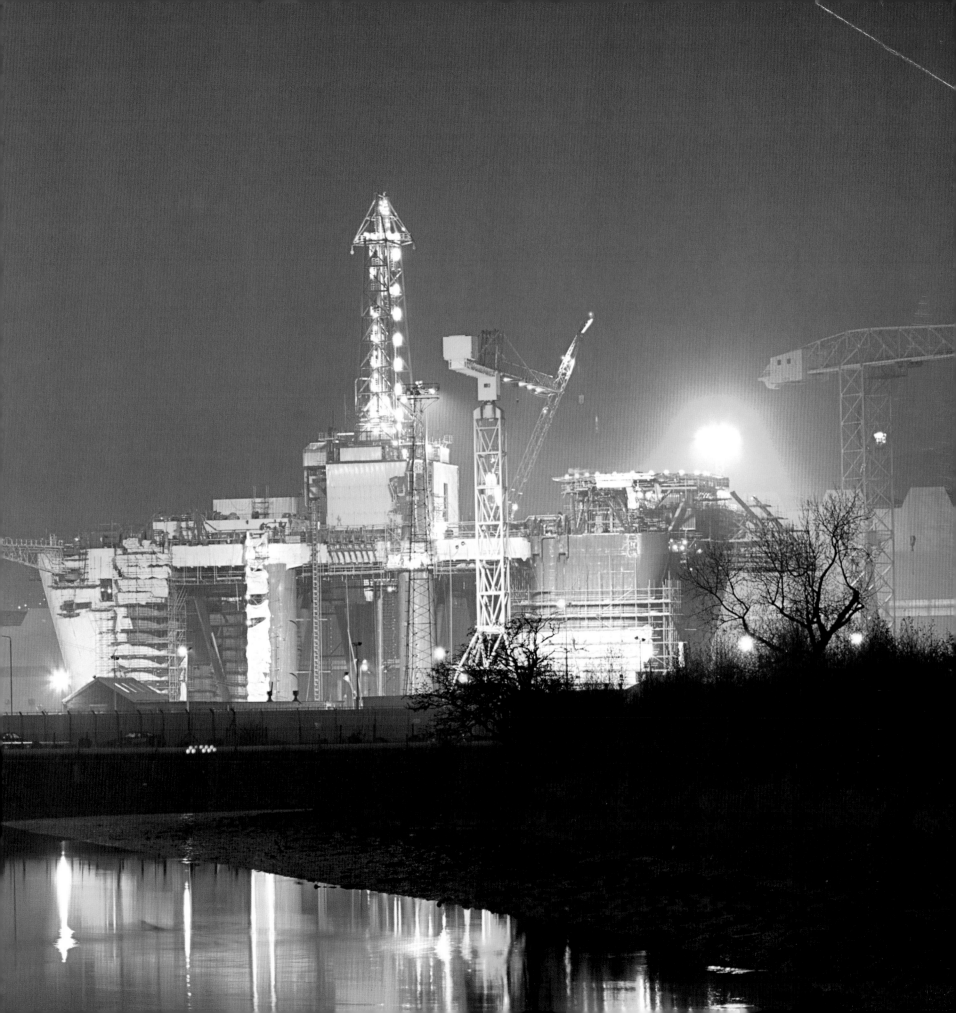

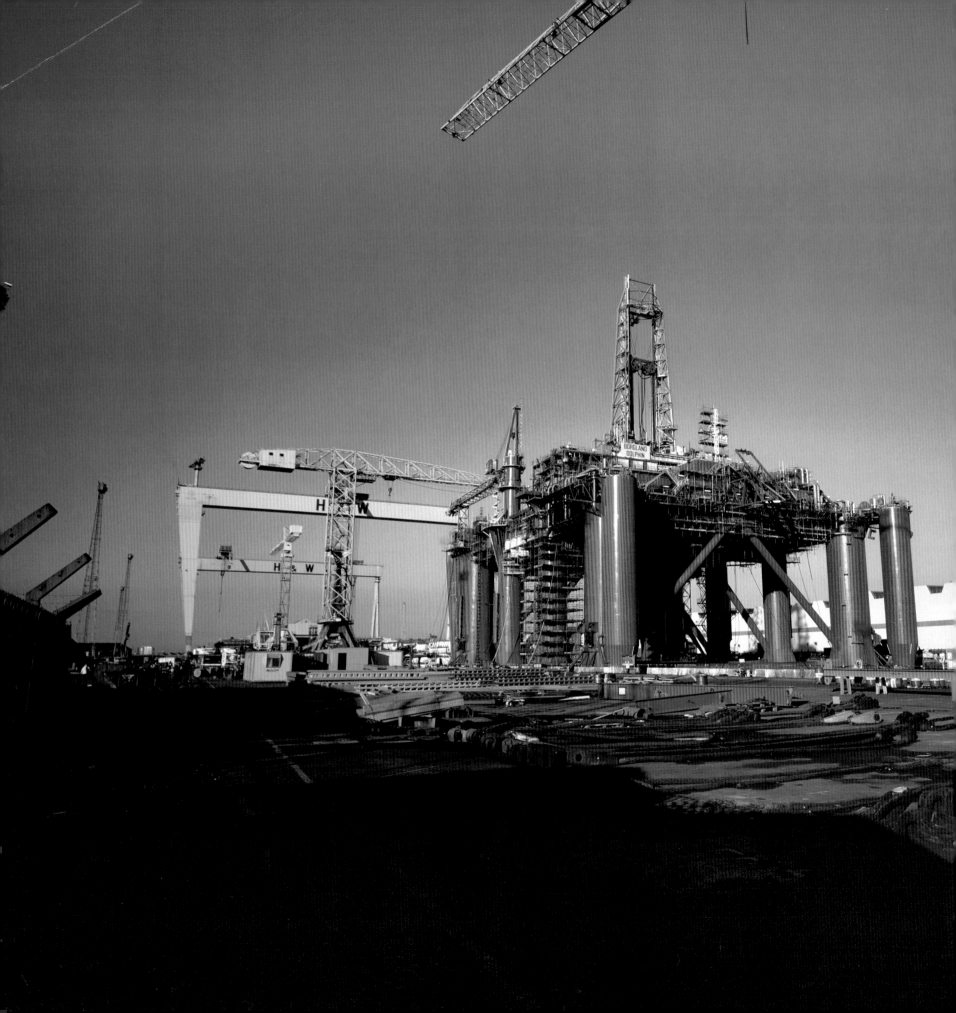

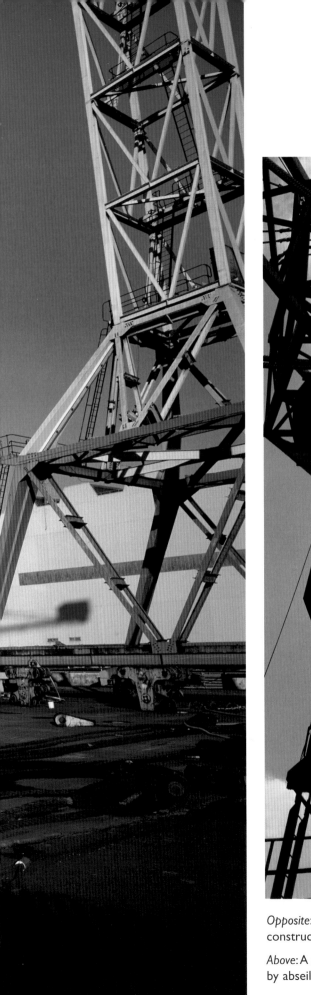

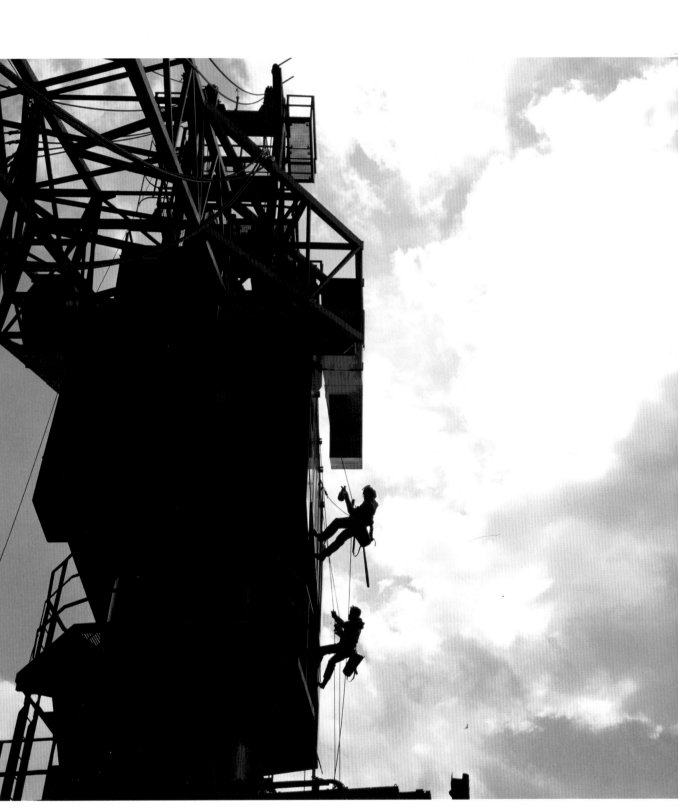

Opposite: A mammoth oil rig under construction at Harland and Wolff

Above: A shipyard crane is spray-painted by abseiling workers.

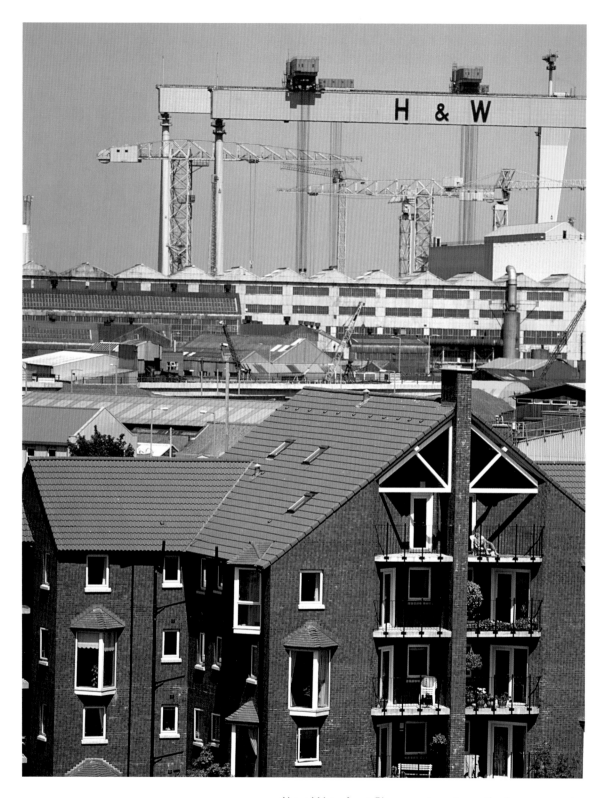

Above: Waterfront Plaza apartments on the Lagan near the Albert Bridge, with the Harland and Wolff shipyard behind

Opposite: Victoria Park, Sydenham. Greylag geese were successfully introduced to the park by Belfast City Council some years ago.

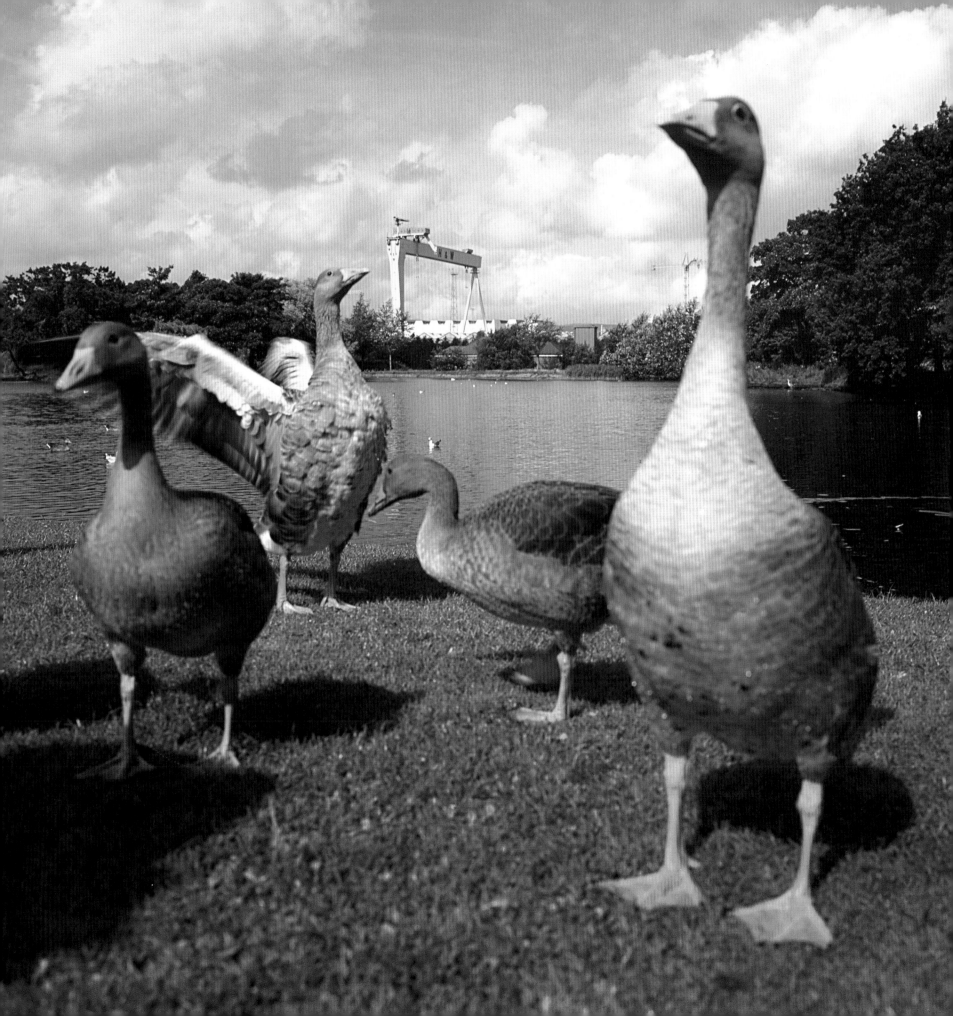

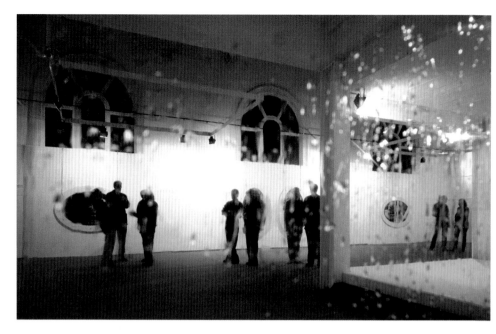

Right: The Engine Room Gallery,
Newtownards Road

Below: The Strand Cinema,
Holywood Road

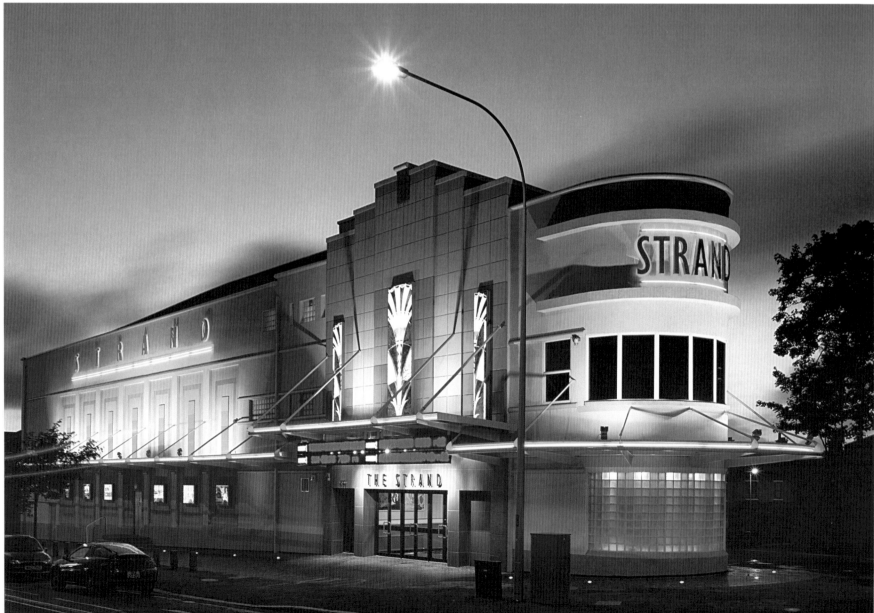

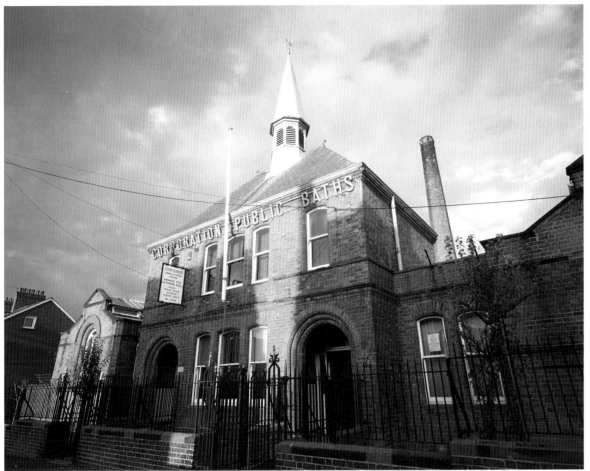

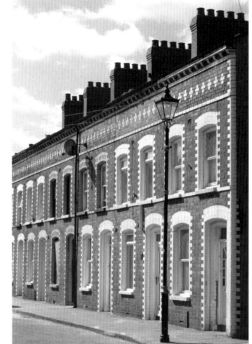

Left: Templemore Baths, east Belfast

Below: Traditional housing in east Belfast

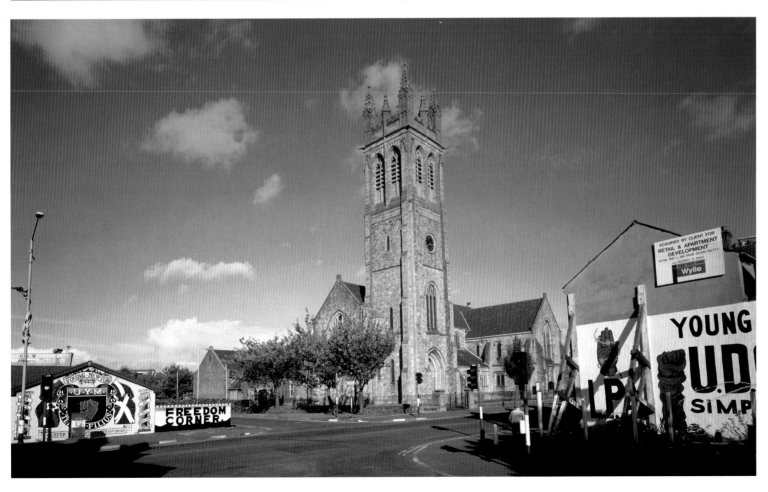

St Patrick's Church,
Newtownards Road 51

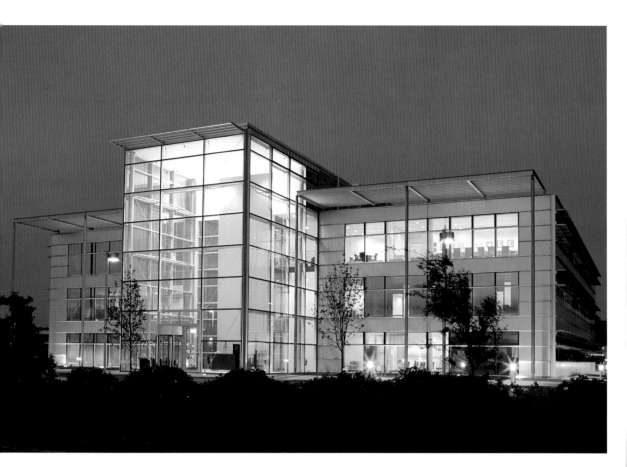

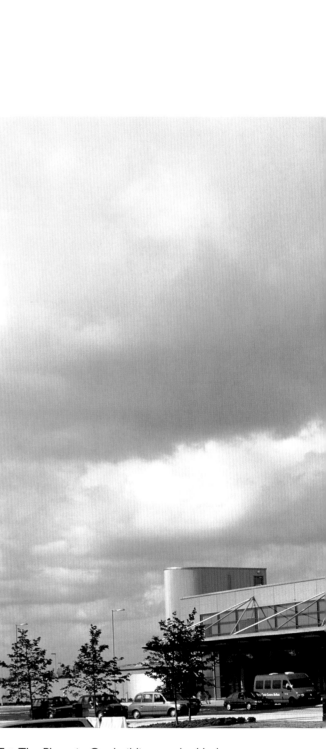

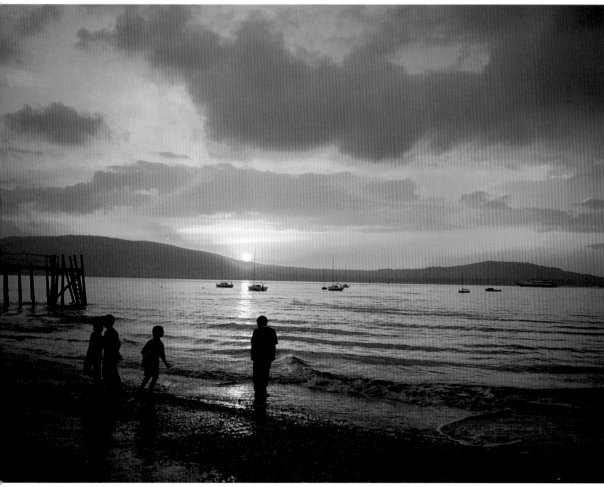

Top: The Phoenix Gas building on the Harbour Estate at Sydenham

Bottom: Belfast Lough at Holywood, with the sun setting over the Antrim Hills

Above: The new Belfast City Airport at Sydenham was opened in 2001.

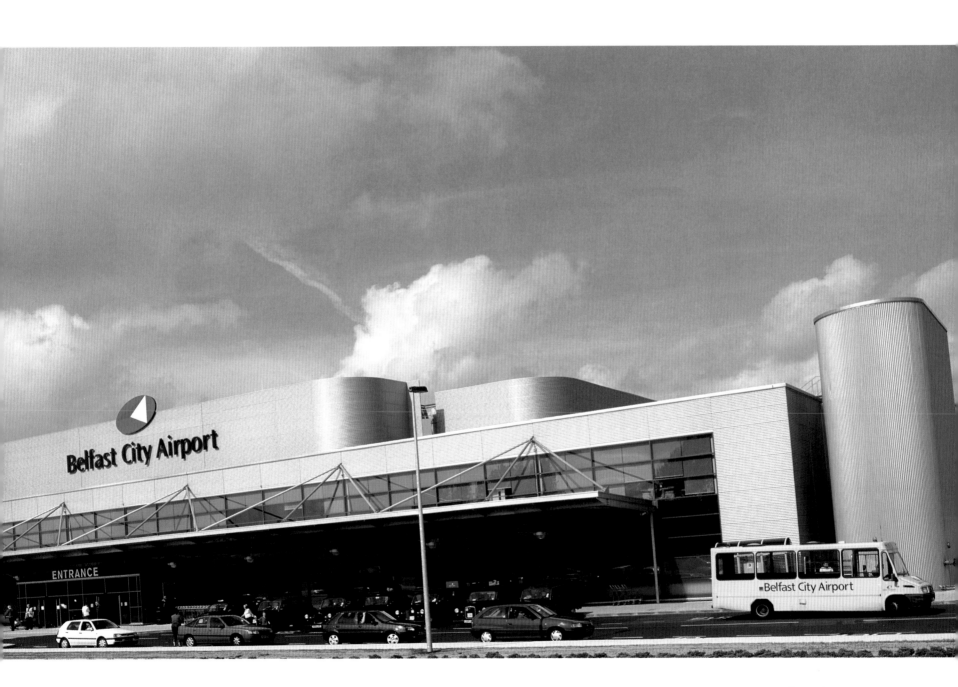

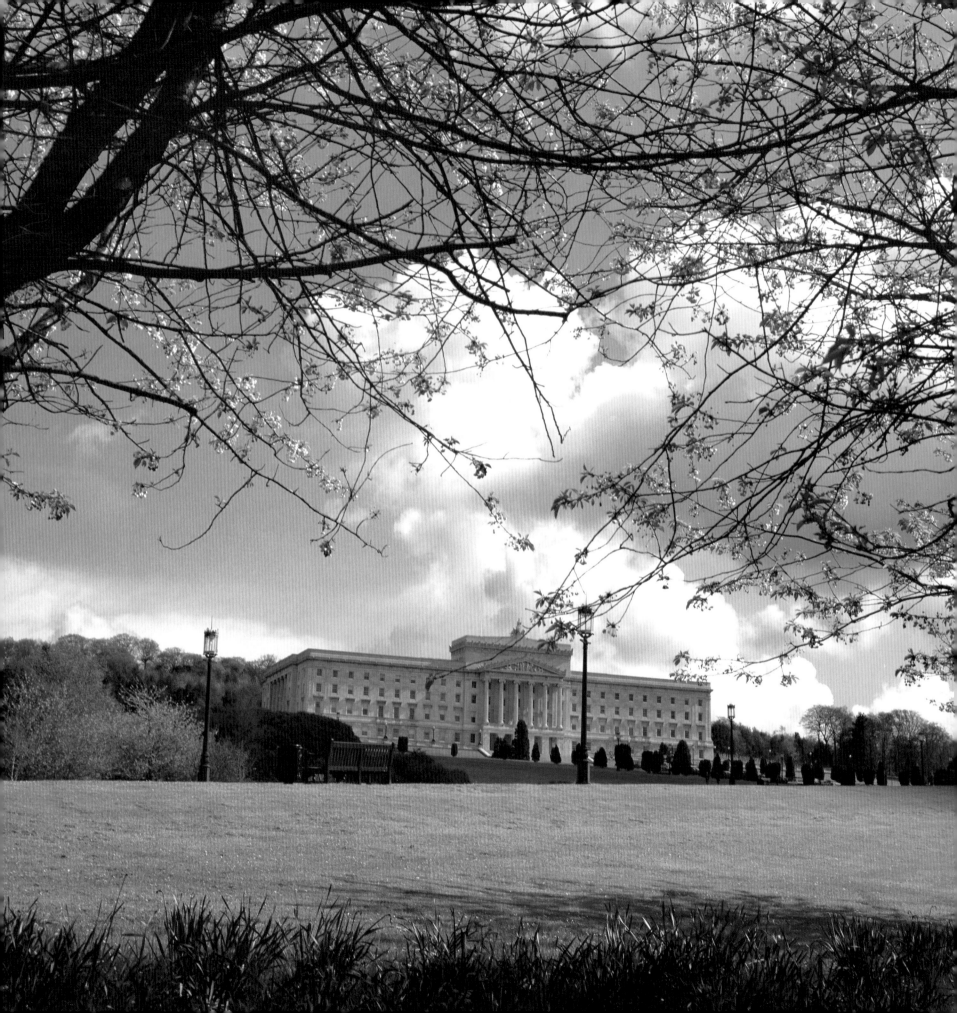

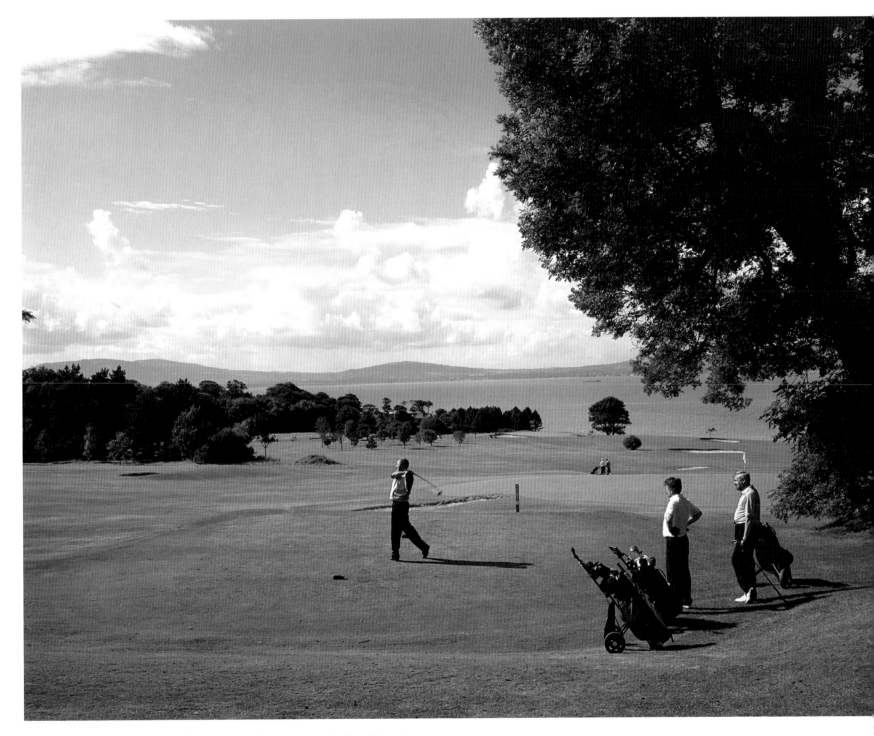

Opposite: Parliament Buildings, Stormont, in the eastern suburbs of the city

Above: Royal Belfast Golf Club on the County Down shore of Belfast Lough

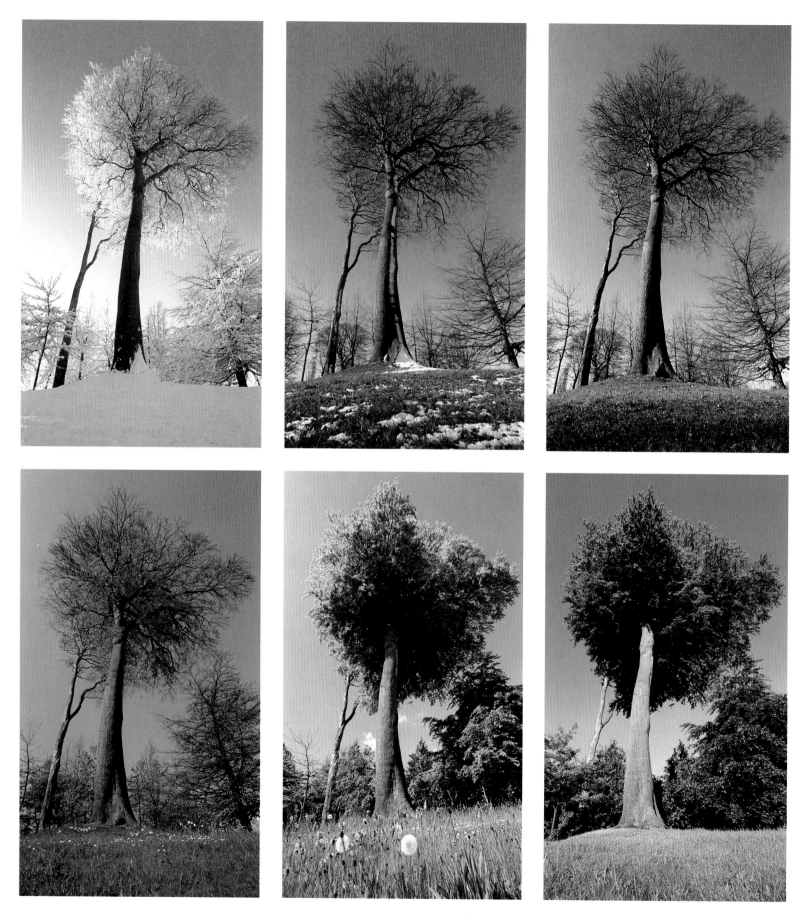

A year's turning from January (*this page top left*) to December
(*opposite page bottom right*) at the Upper Malone roundabout

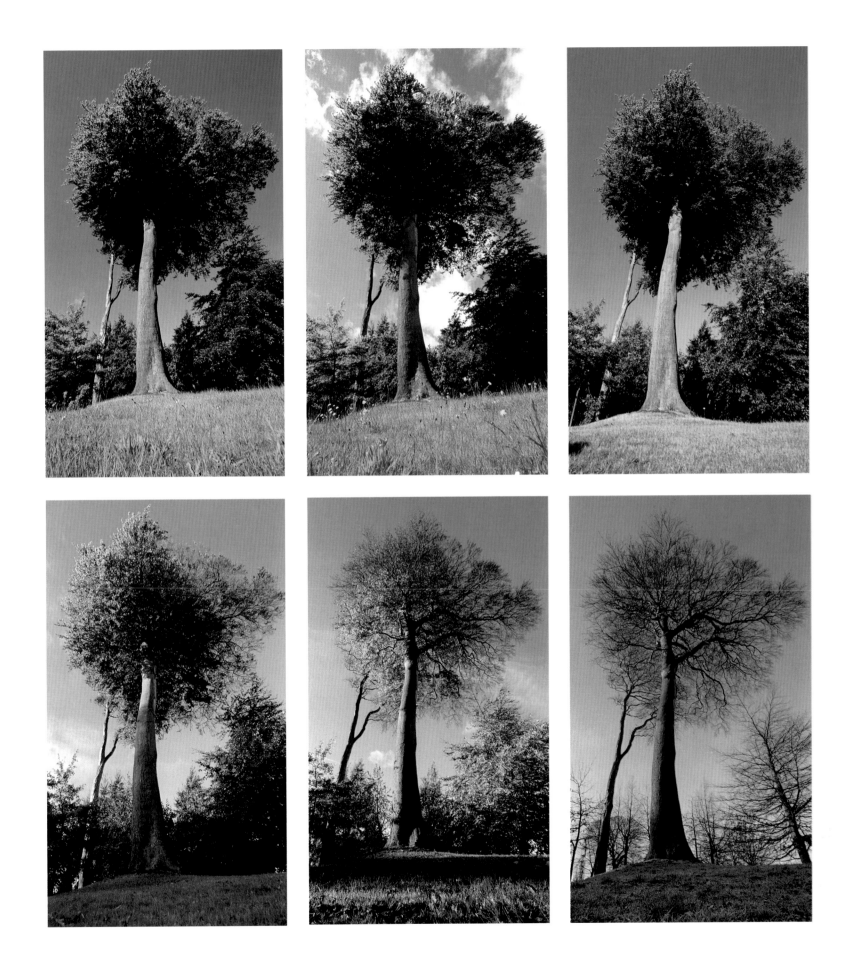

MacArt's Fort, the most prominent feature
of the Cavehill, dominates the skyline to the
north of the city

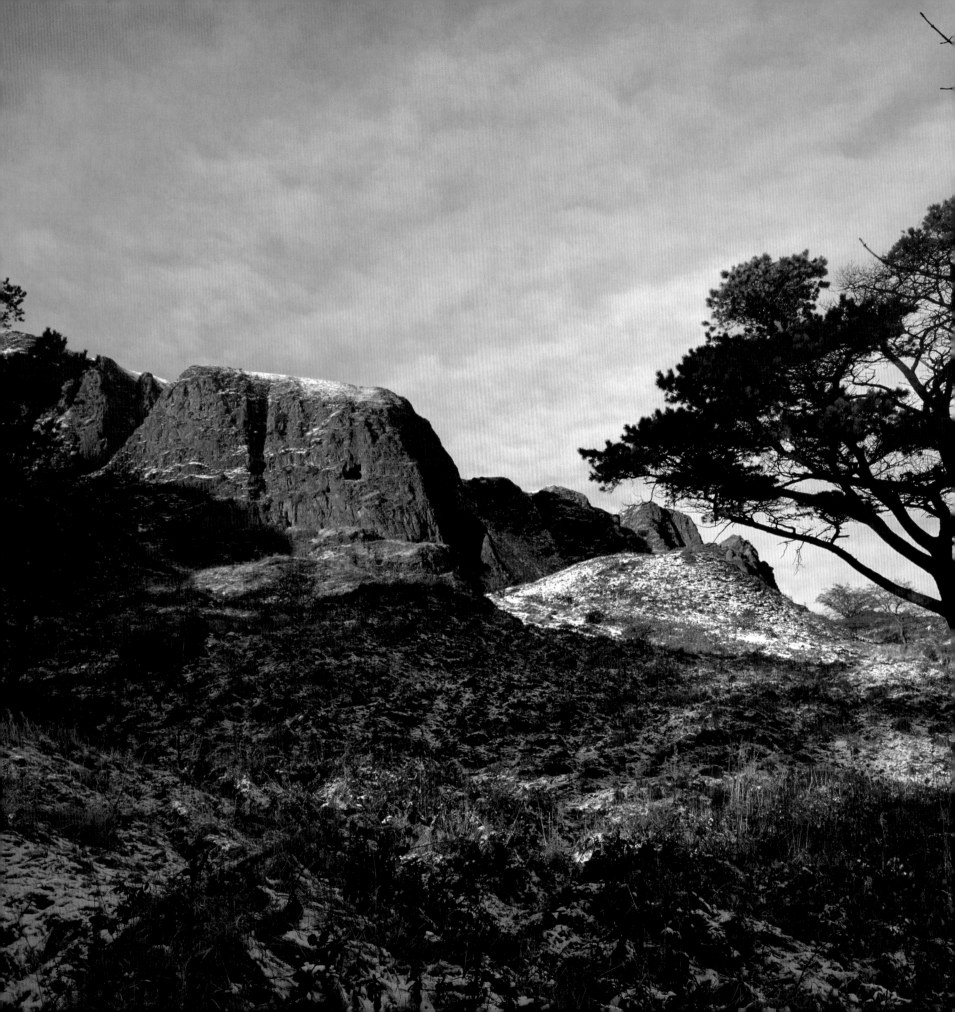

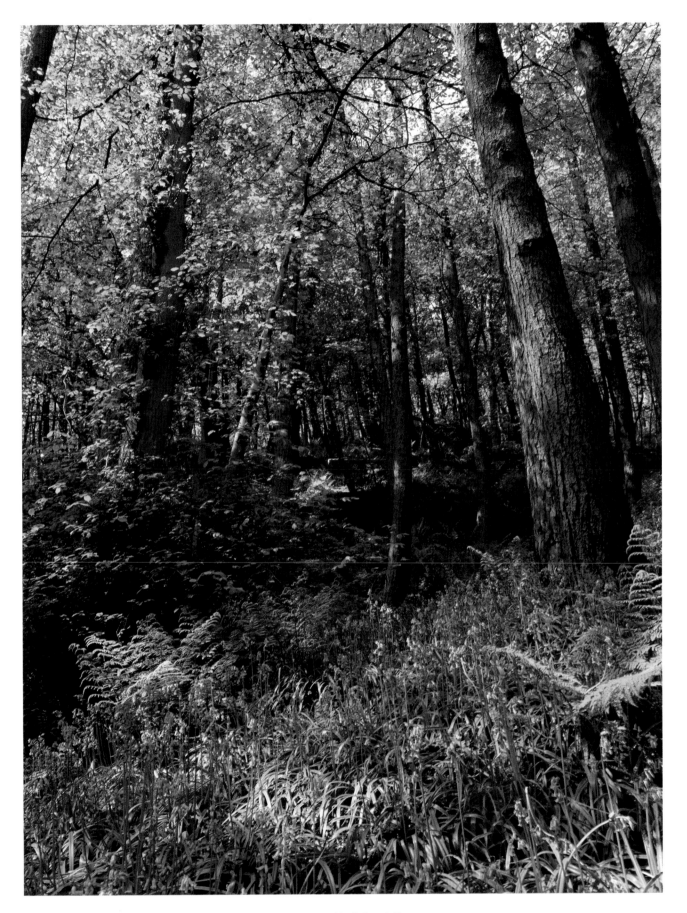

Above: Spring brings the bluebells back to the ancient woods of Cavehill.

Opposite: The caves which give Cavehill its name are clearly seen in the crags at the summit.

Belfast Zoo in
its splendid setting
on Cavehill

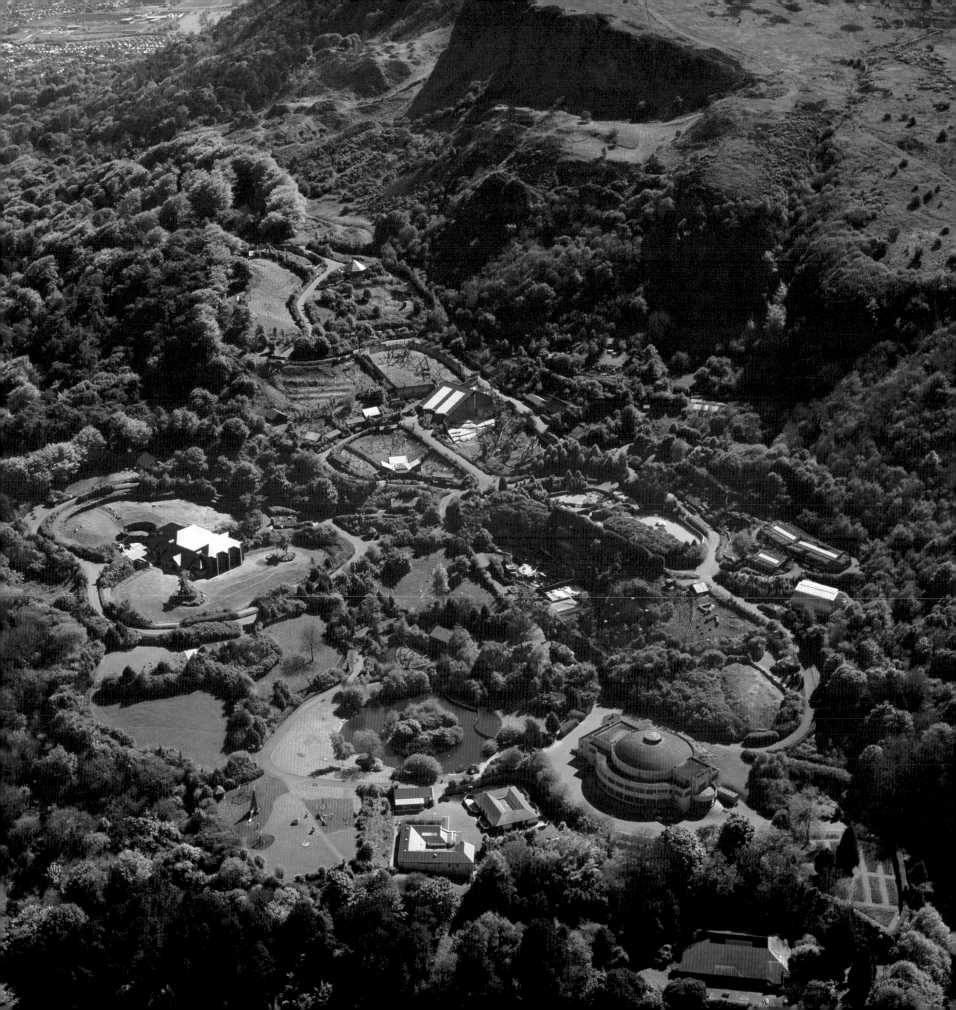

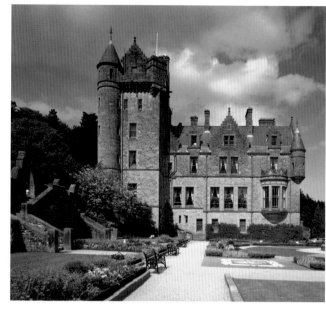

Belfast Castle on the Cavehill.
Owned by Belfast City Council,
it offers spectacular views over
Belfast and its sea lough

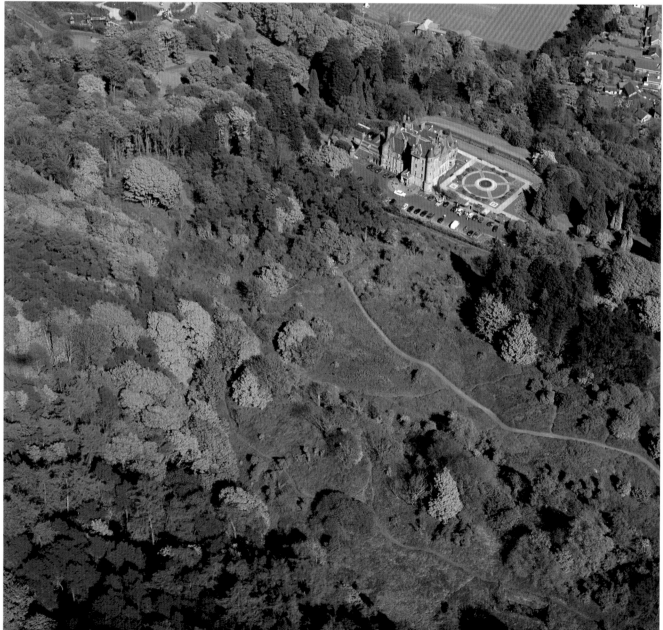

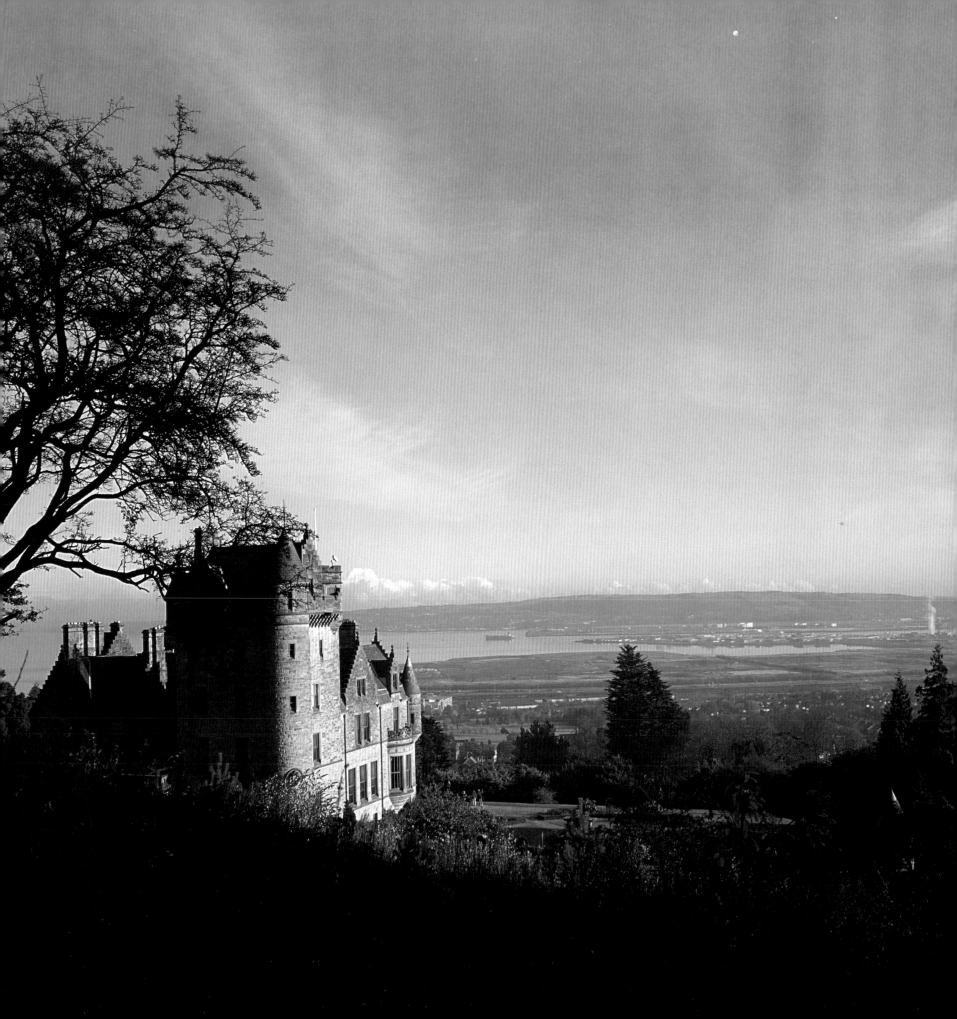

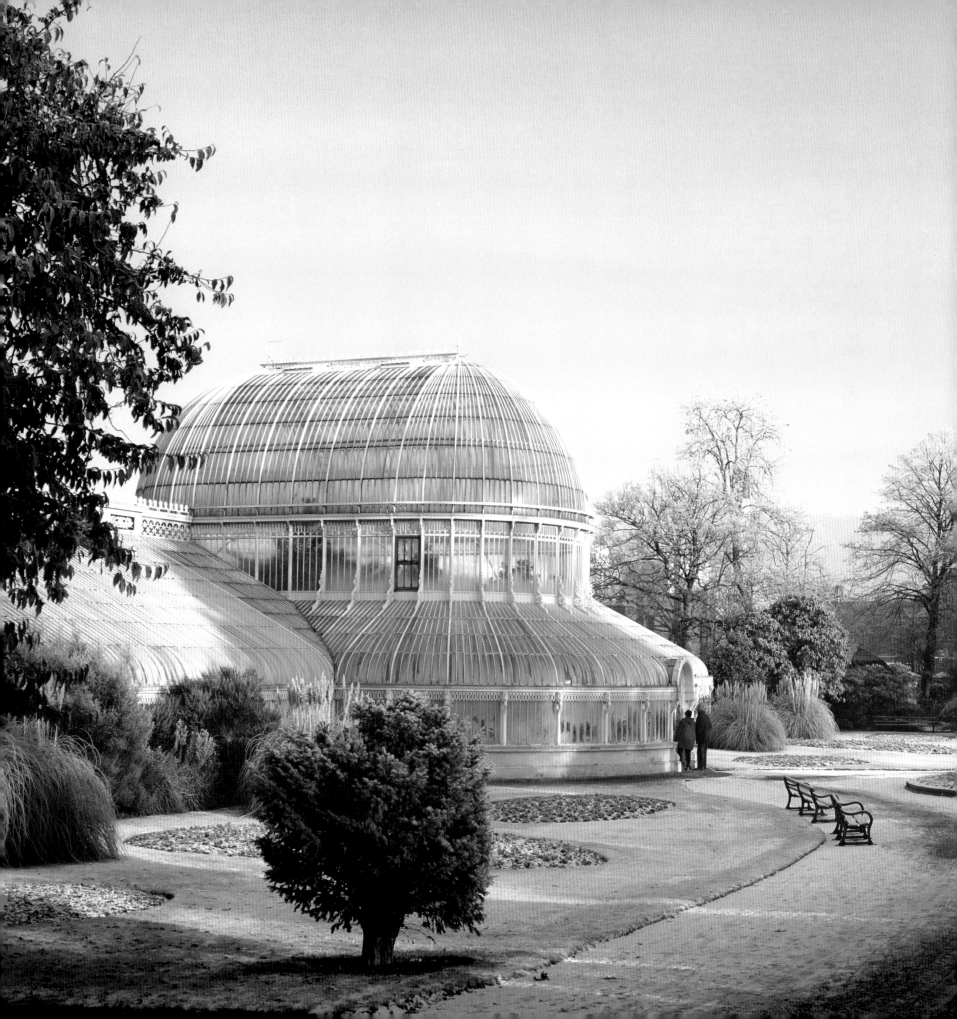

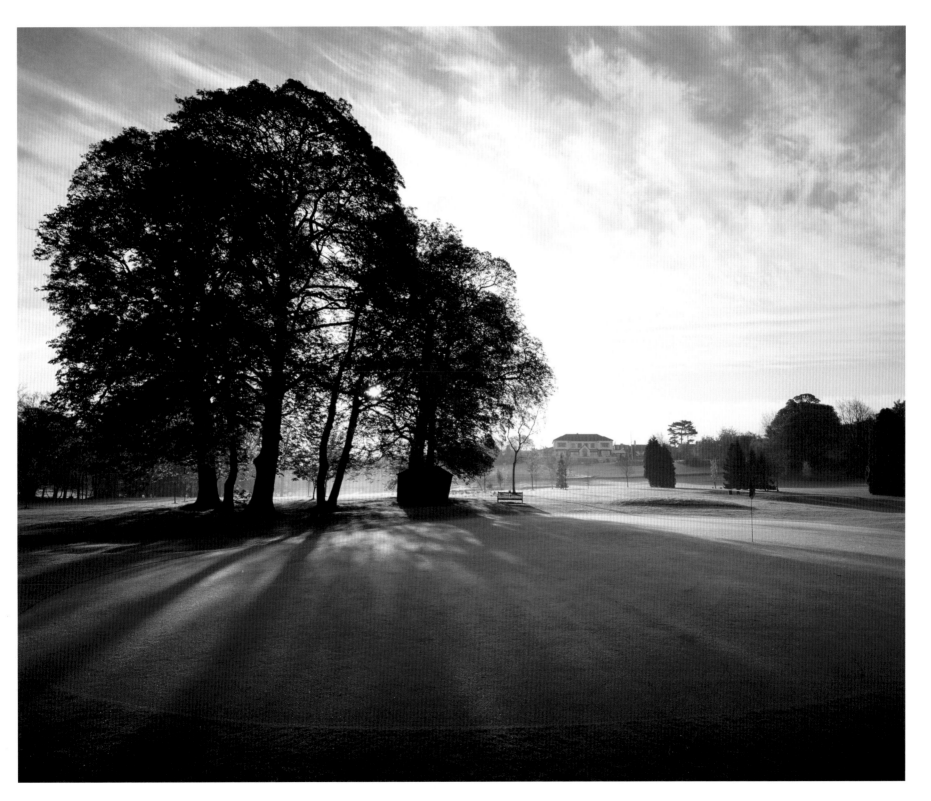

Opposite: The graceful Victorian Palm House
at Botanic Gardens in south Belfast

Above: Belvoir Golf Club in south Belfast

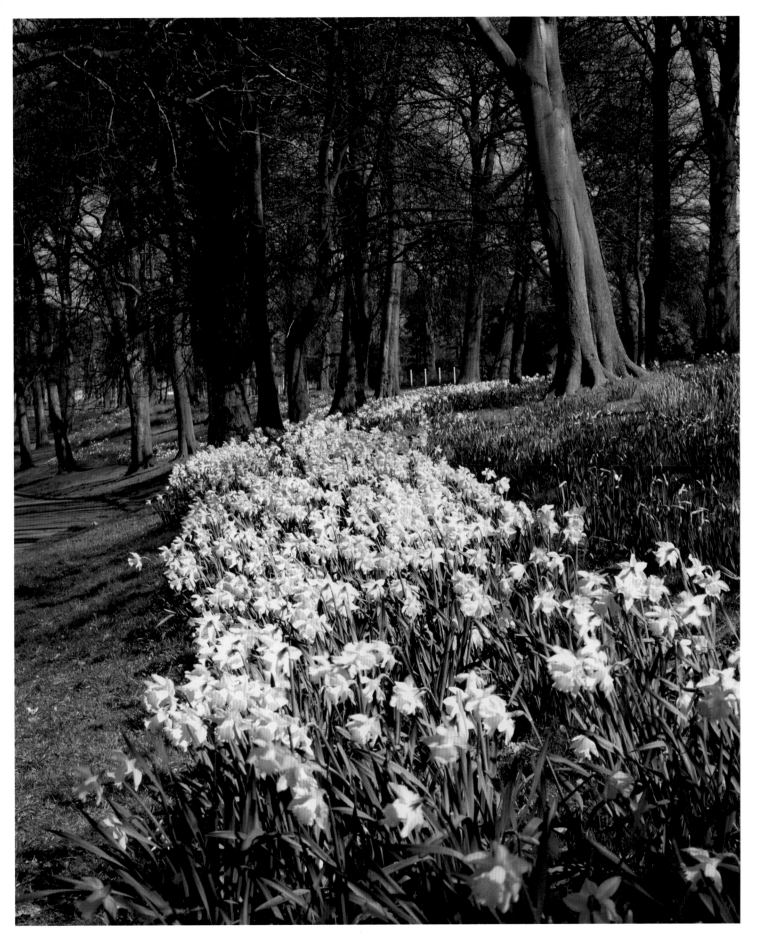

Bordering the river Lagan on the south side of the city, Ormeau Park has brought a breath of fresh air to generations of Belfast people.

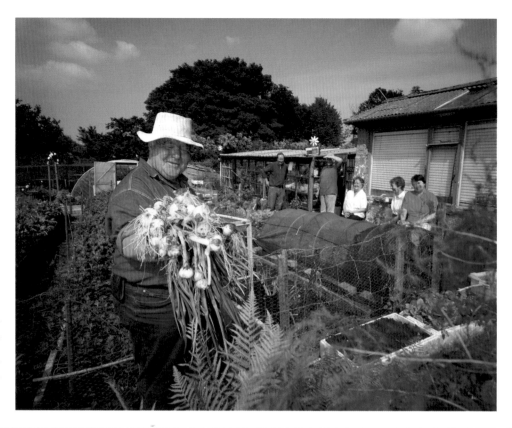

Right: Harvest time at the allotments at Annadale Embankment

Below: The International Rose Trials at Sir Thomas and Lady Dixon Park at Upper Malone attract experts from all over the world every July.

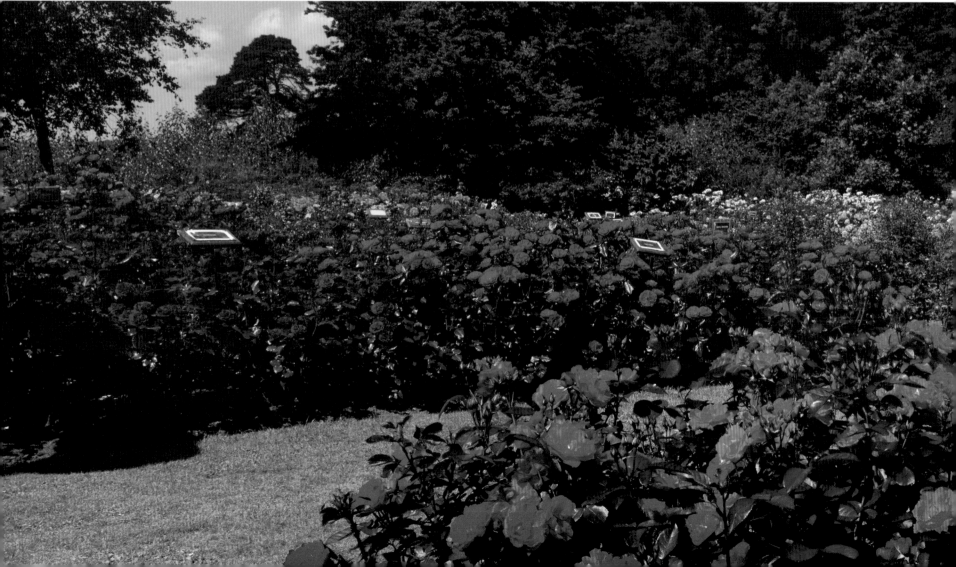

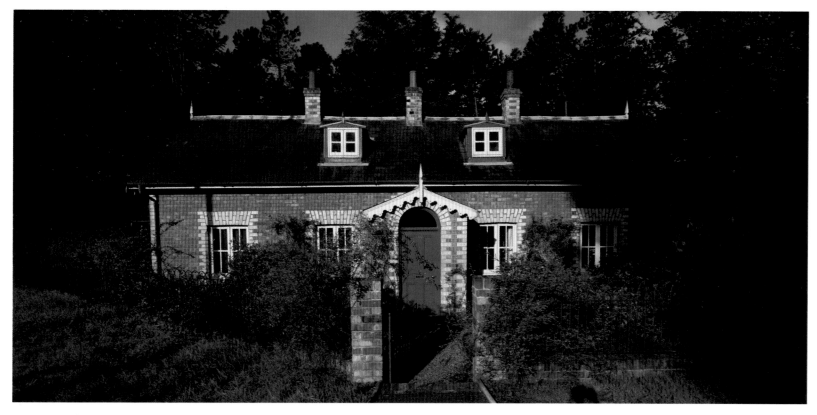

At the edge of the Park, three estate labourers' cottages have been converted into one rather more spacious home.

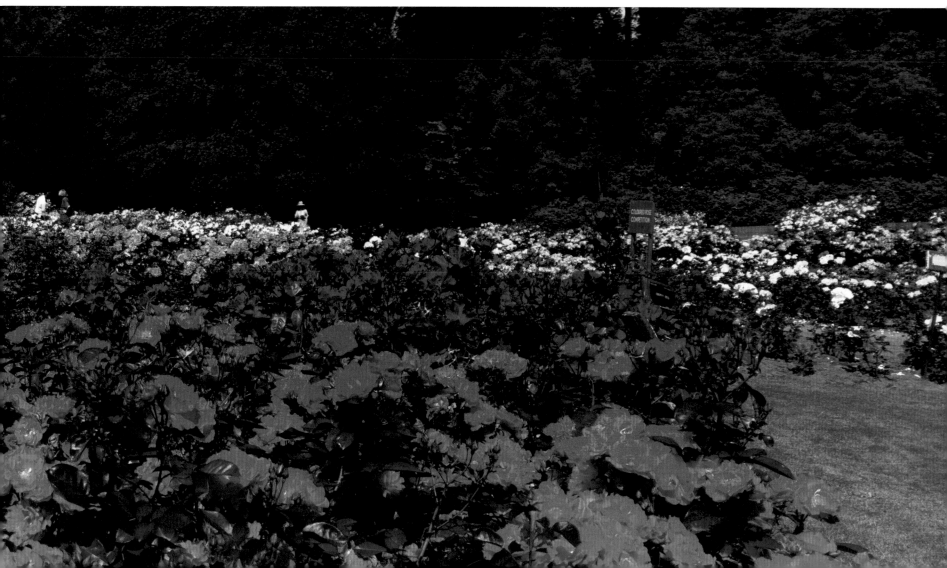

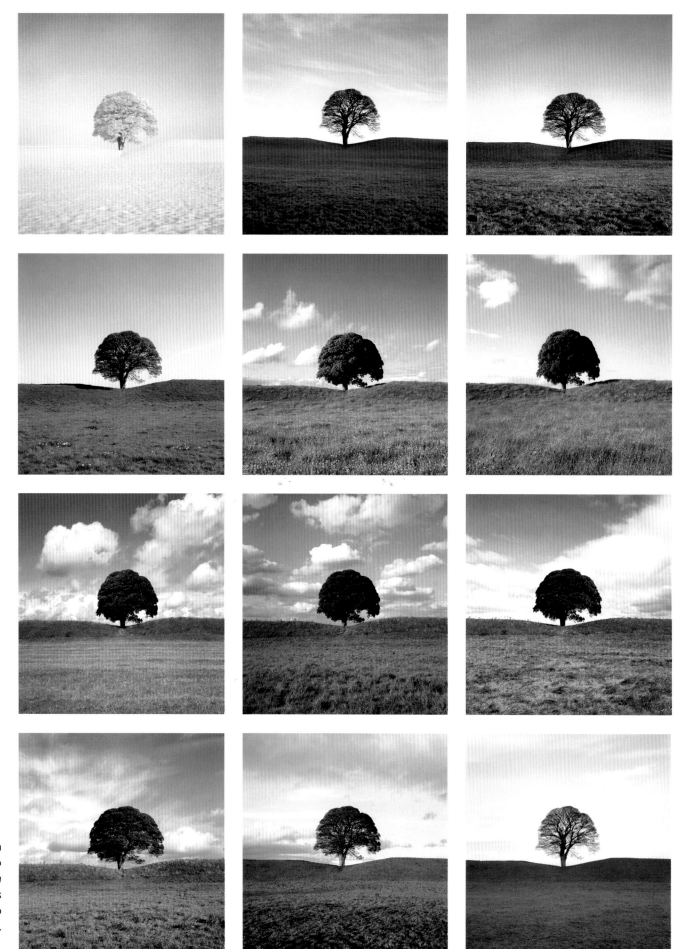

Changing seasons from January (*top left*) to December (*bottom right*) at the Giant's Ring near Edenderry to the south of the city.

72

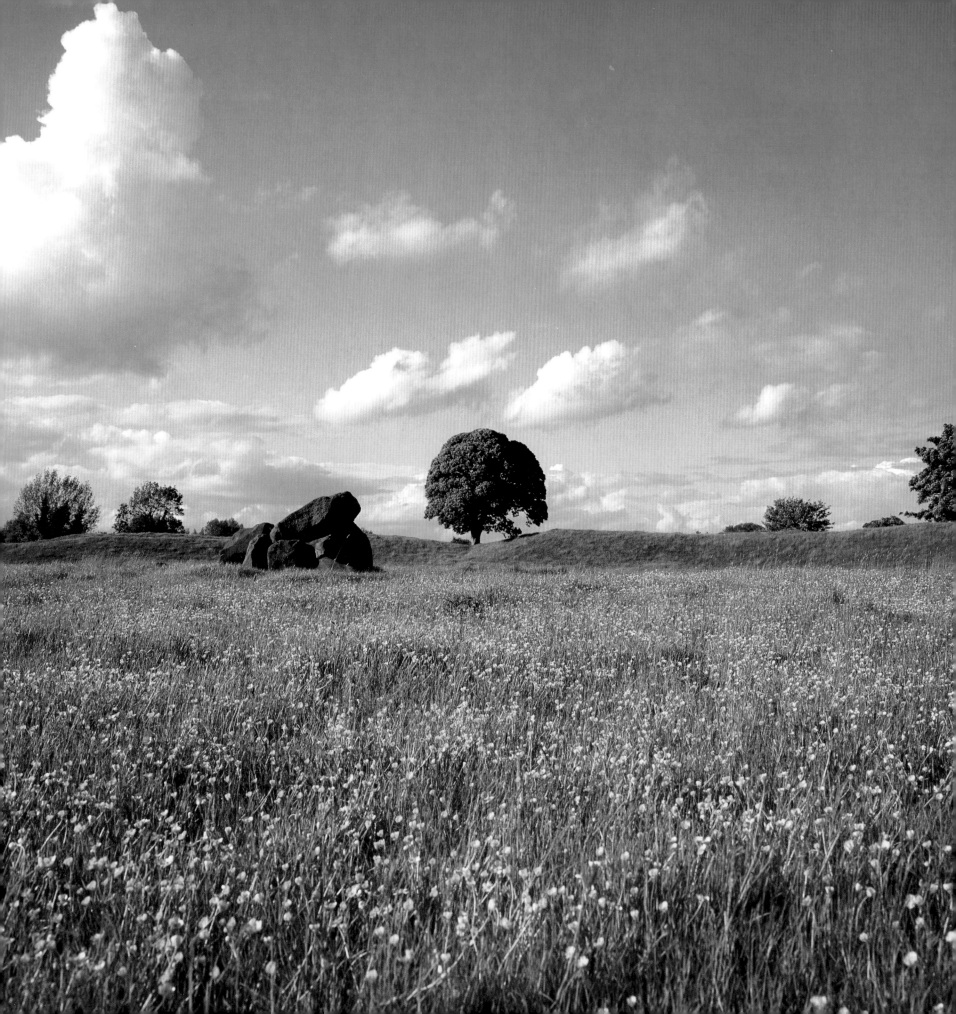

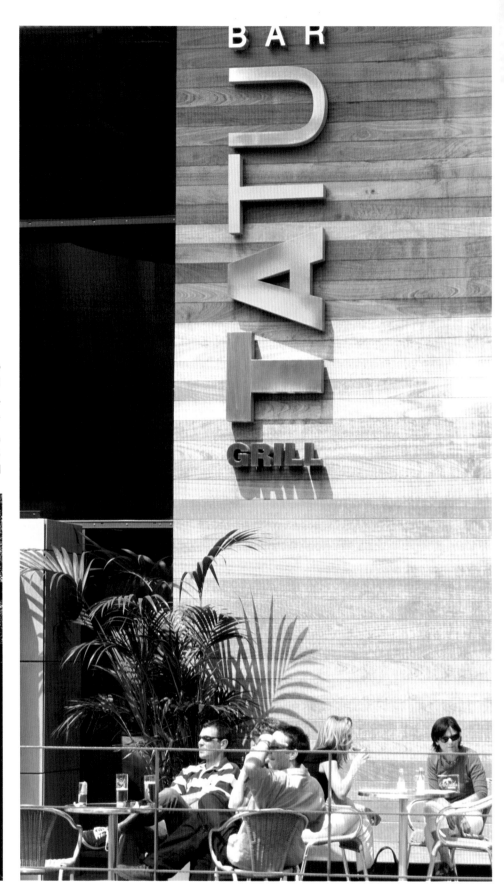

Opposite: Behind the striking Art Deco façade of the King's Hall at Balmoral are commodious venues for concerts, exhibitions and agricultural shows.

The new Belfast – café society on (*right*) Lisburn Road and (*below*) Stranmillis Road

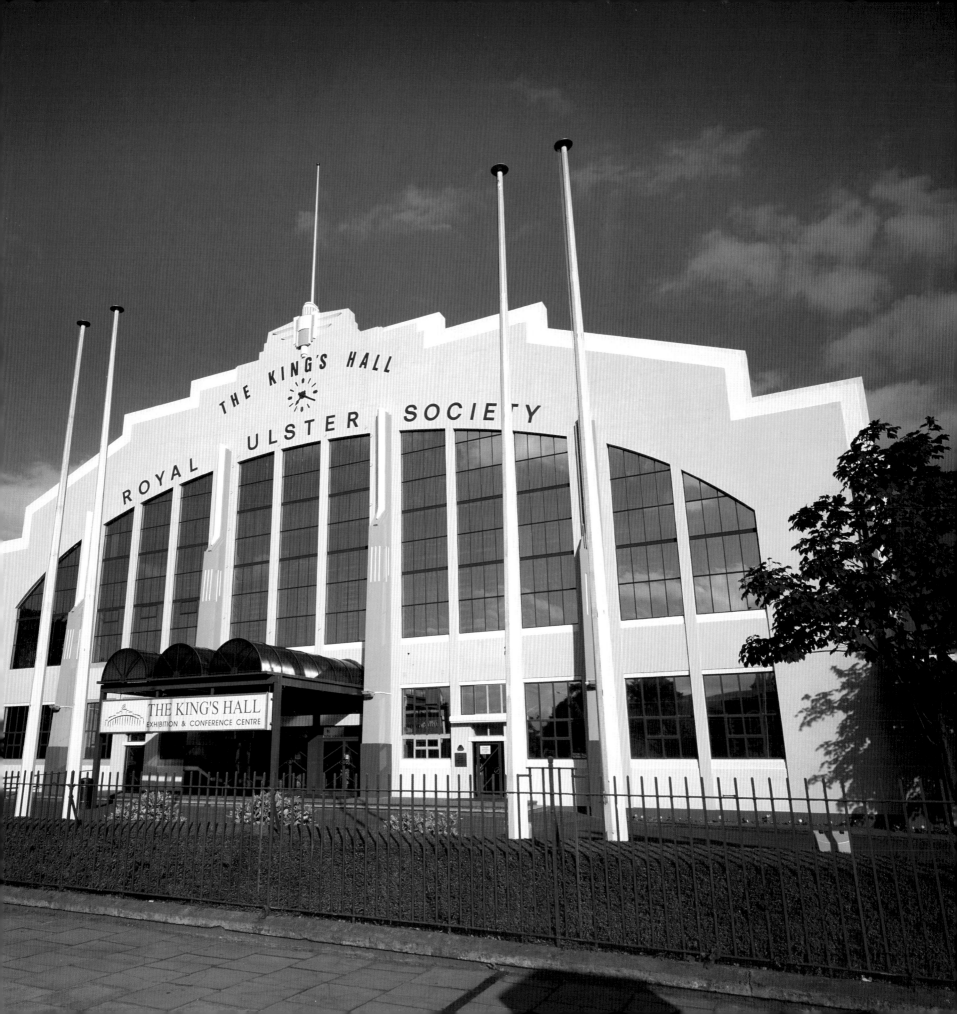

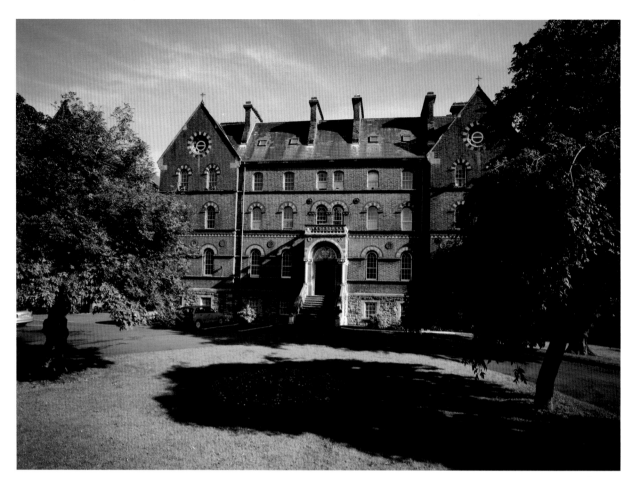

Right: St Dominic's High School, Falls Road

Below: Campbell College, Belmont Road

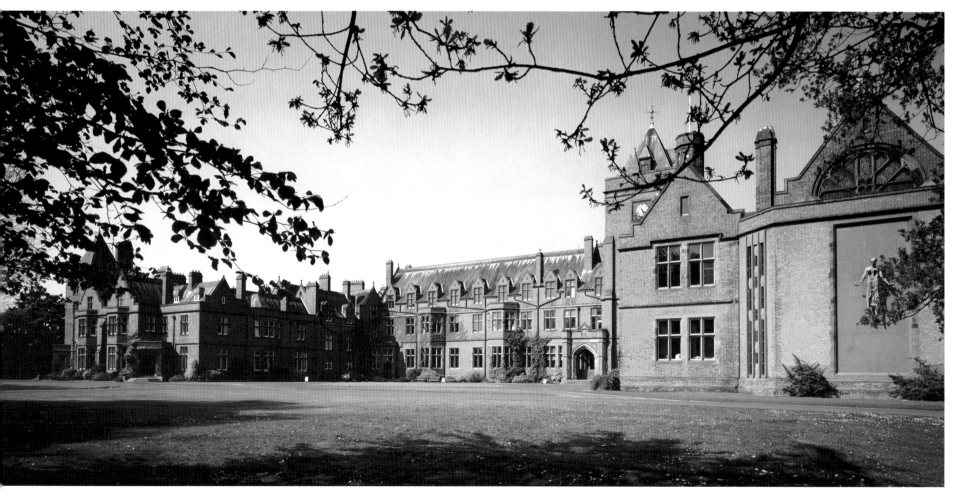

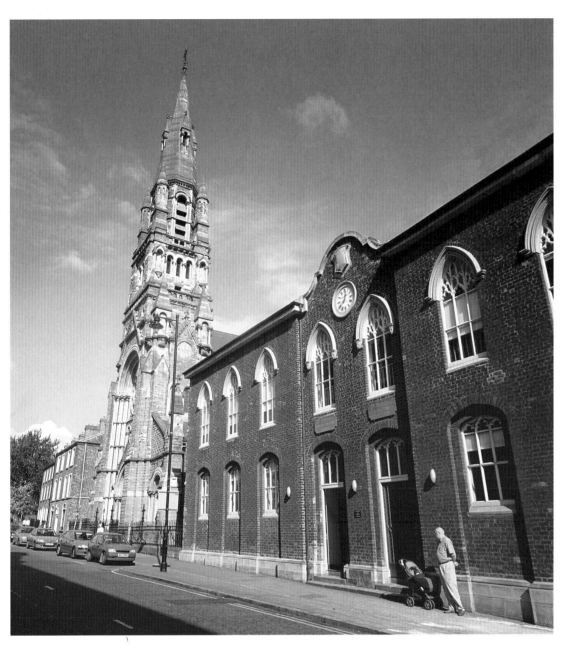

Left: St Patrick's Church, Donegall Street. The building nearest the camera was originally St Patrick's National School, but now houses the CCMS offices and the Diocesan Bookshop.

Below: The Royal Belfast Academical Institution, College Square East, one of the city's oldest grammar schools and popularly known as 'Inst'.

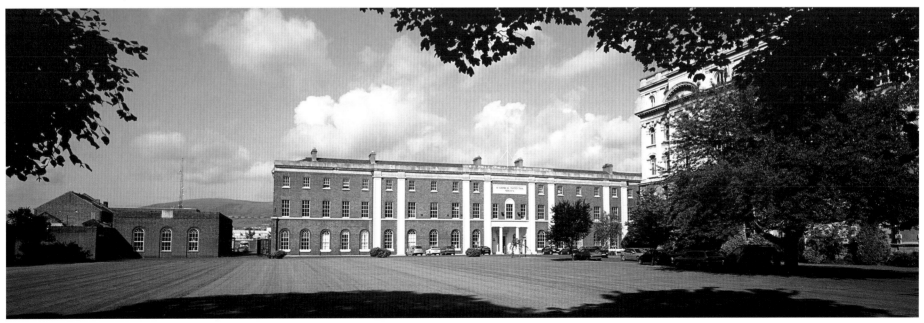

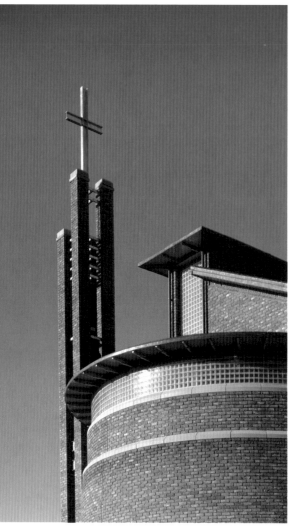

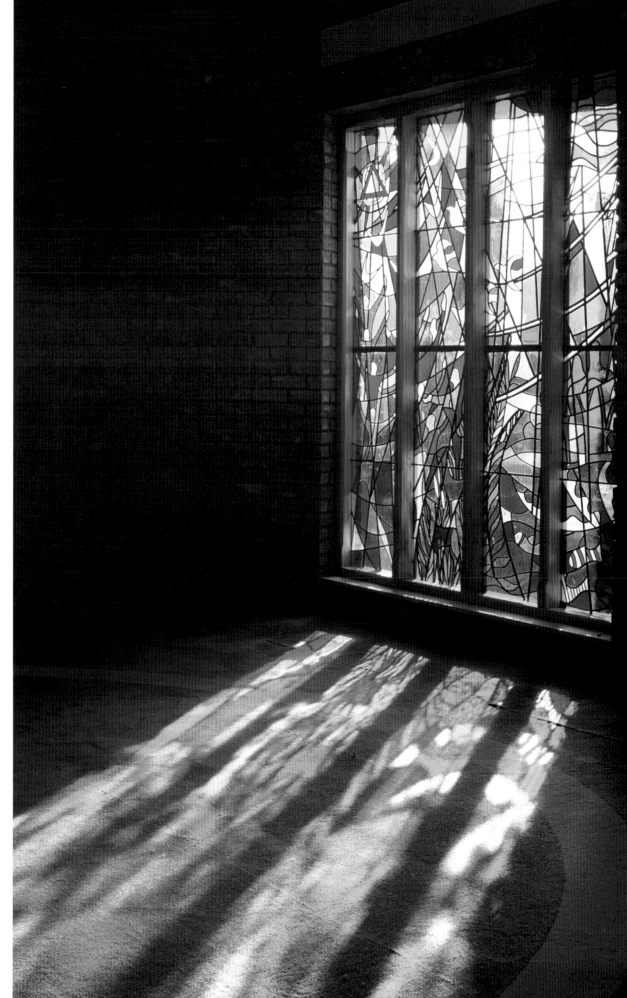

Above and right:
St Brigid's Church, Derryvolgie Avenue

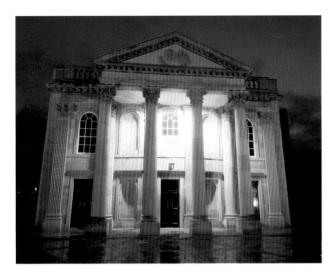

Left: St George's Church, High Street

Below: The curved interior of Rosemary Street First Presbyterian Church in the city centre

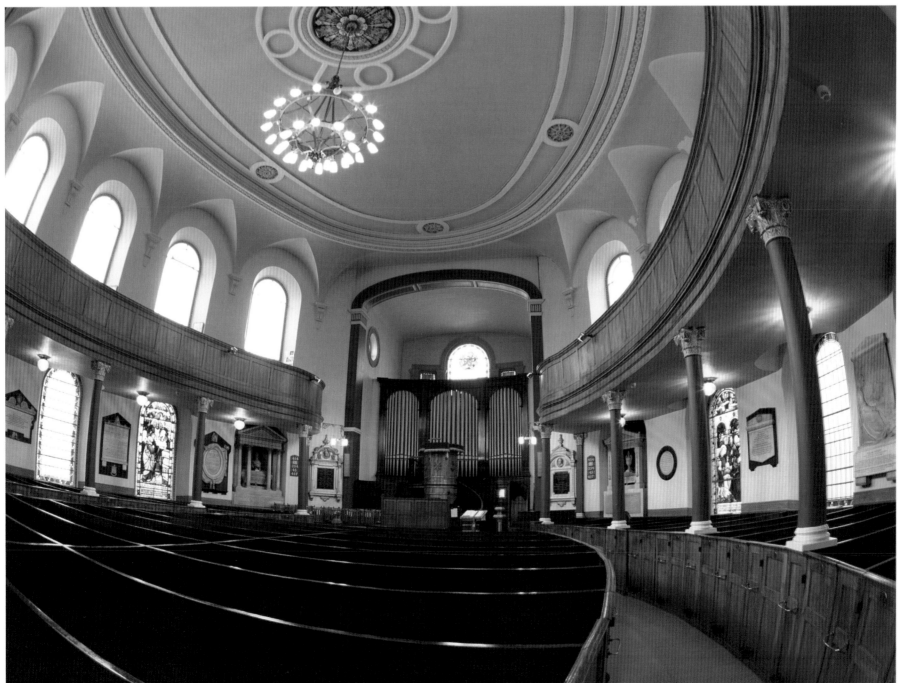

The Carnegie Library, Donegall Road, now refurbished and used as office accomodation

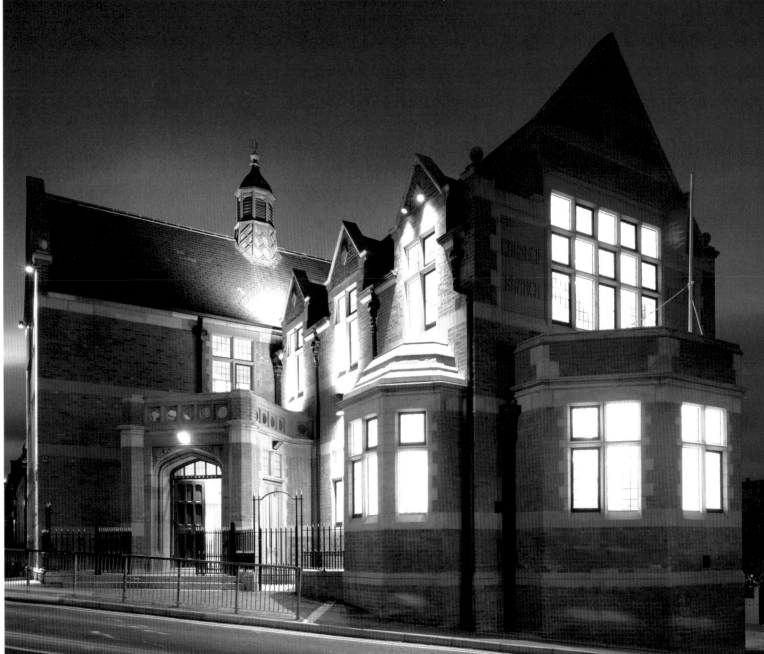

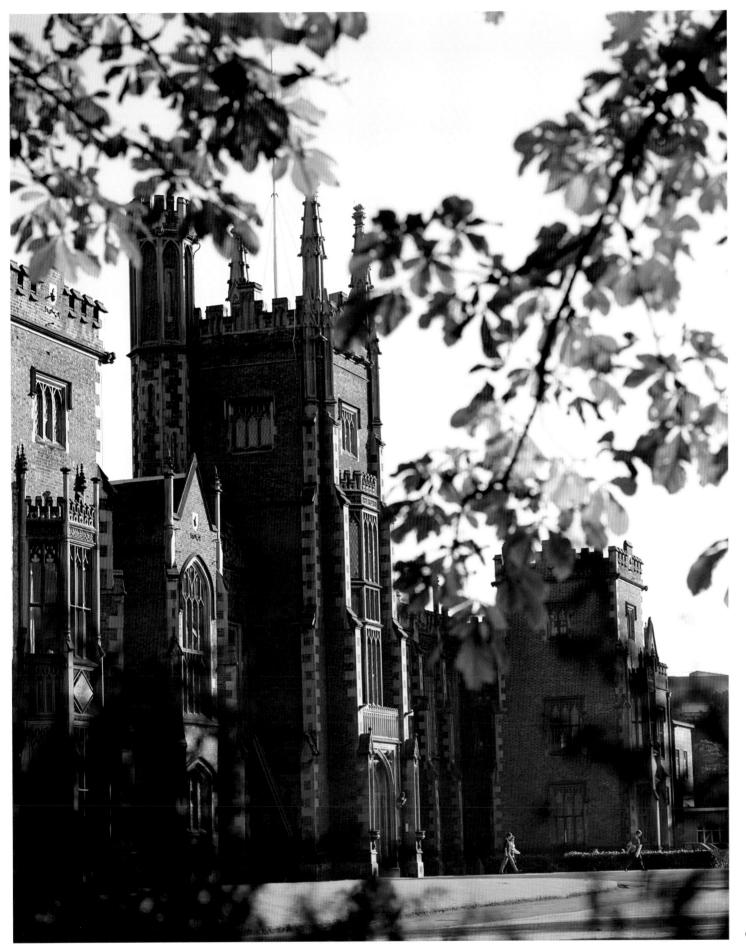

The new main building of the Royal Victoria Hospital in west Belfast was opened in 2001.

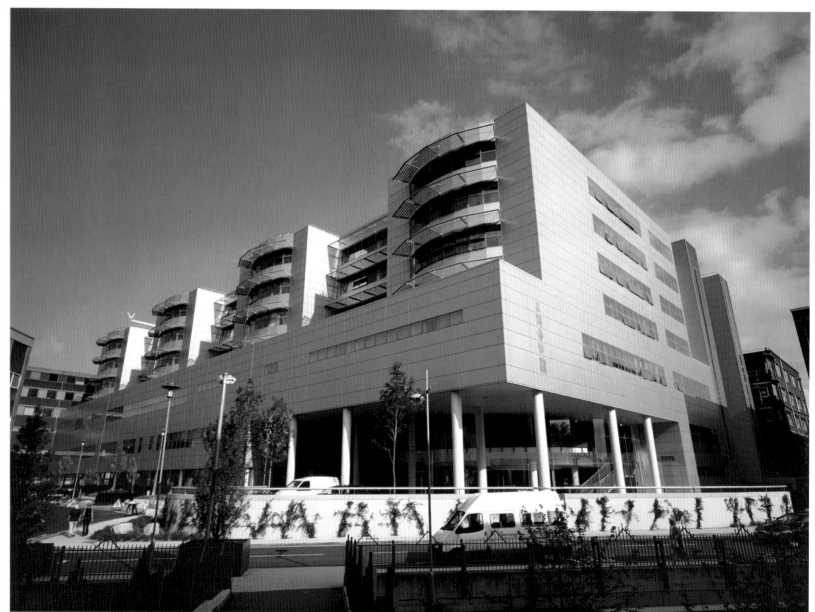

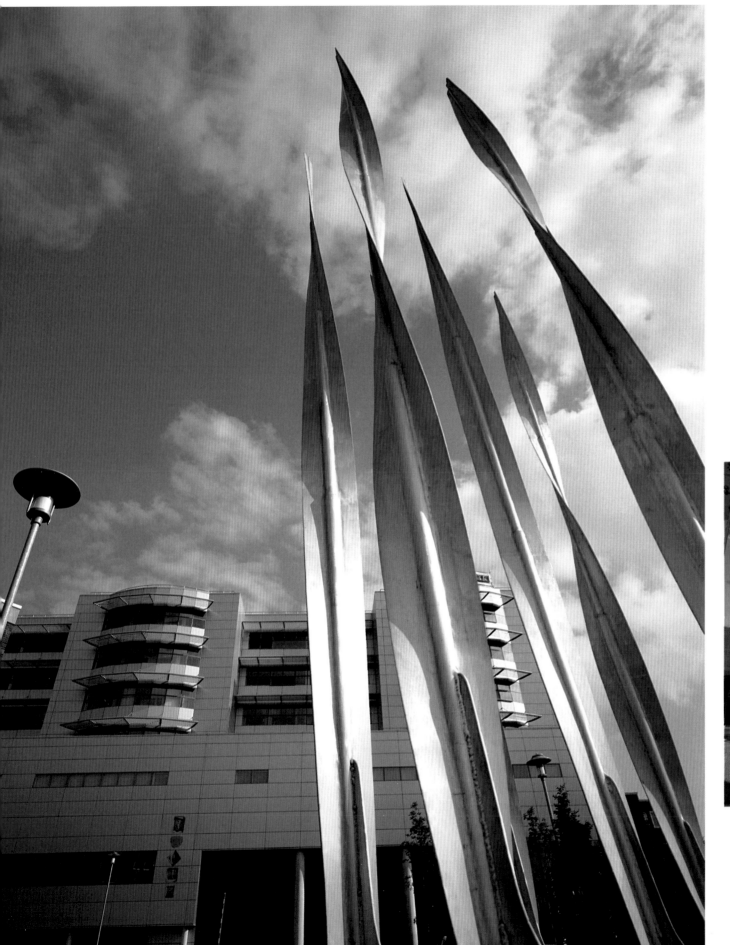

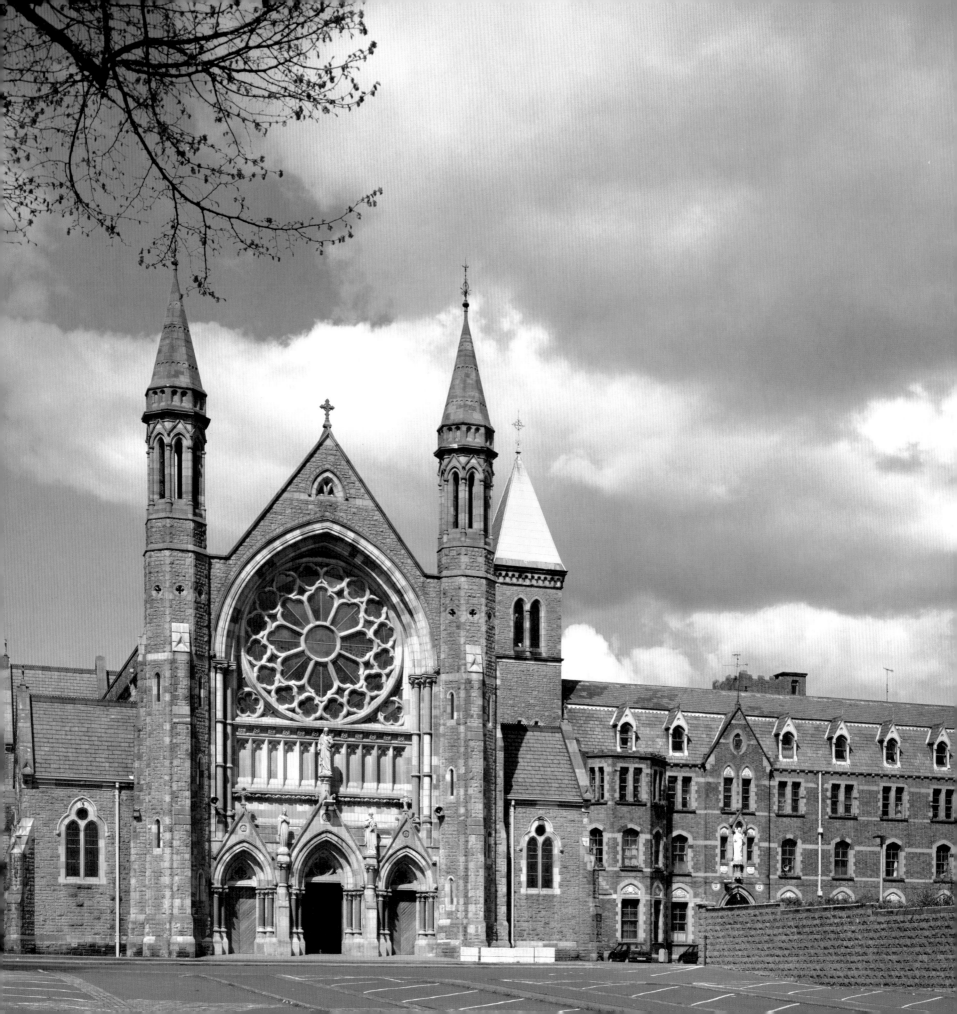

Clonard Monastery on the
Lower Falls

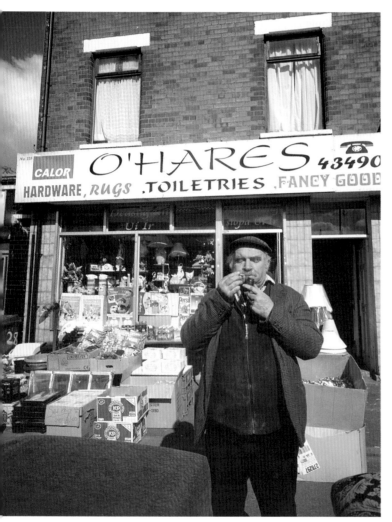

Above: All kinds of everything on the Falls

Right: West Belfast Festival parade,
Falls Road

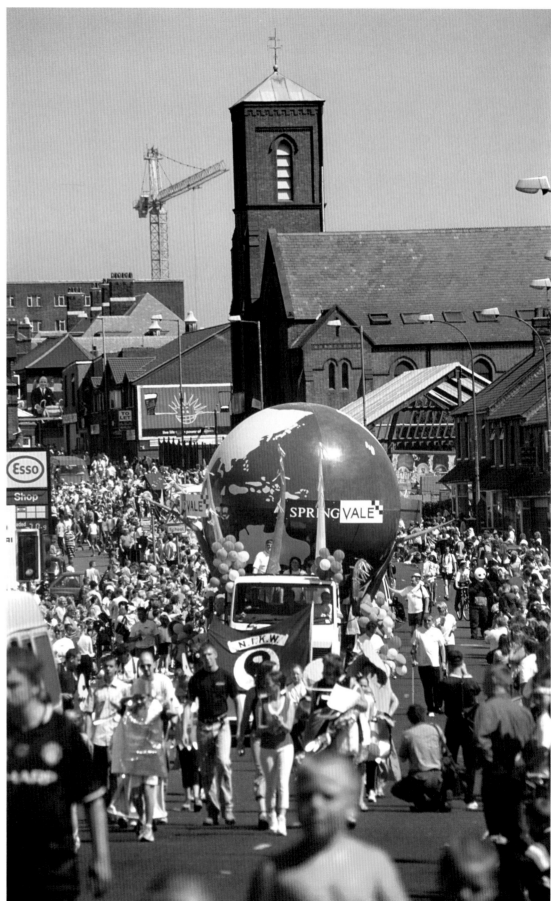

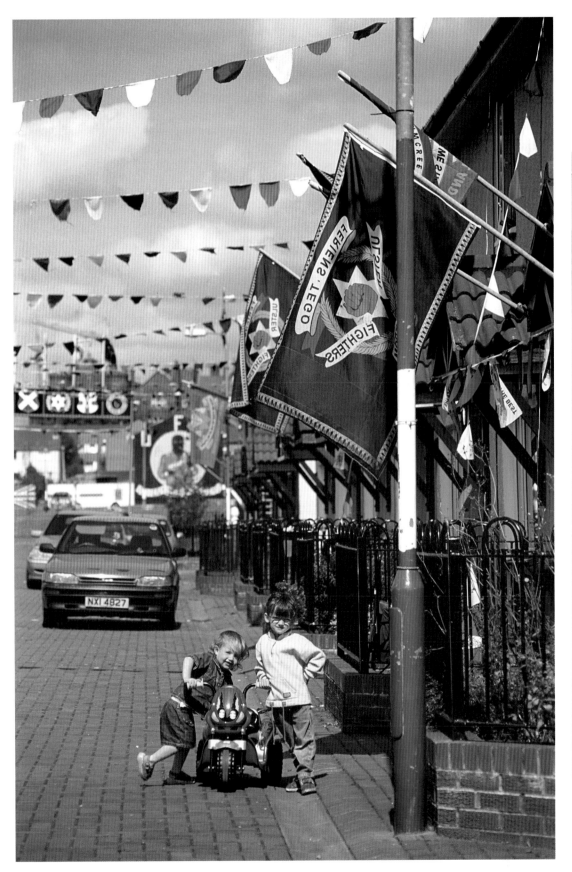

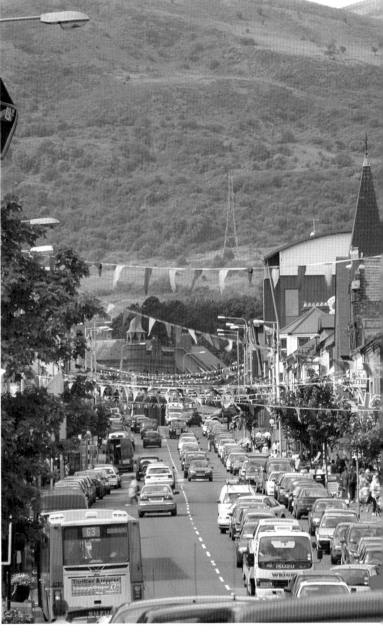

Above: Shankill Road as it climbs toward Divis Mountain

Left: Young Shankill residents

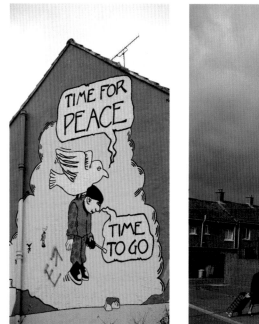

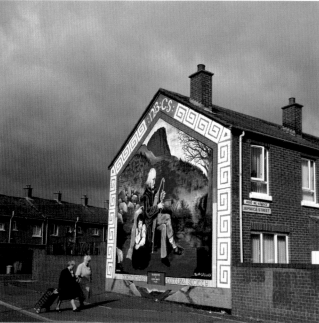

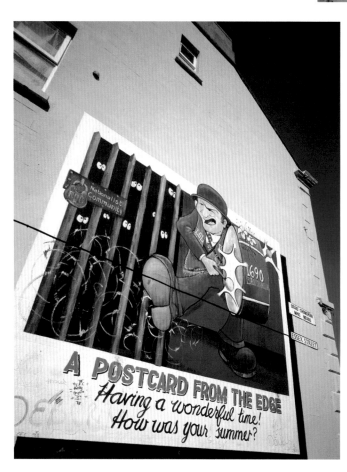

Republican murals

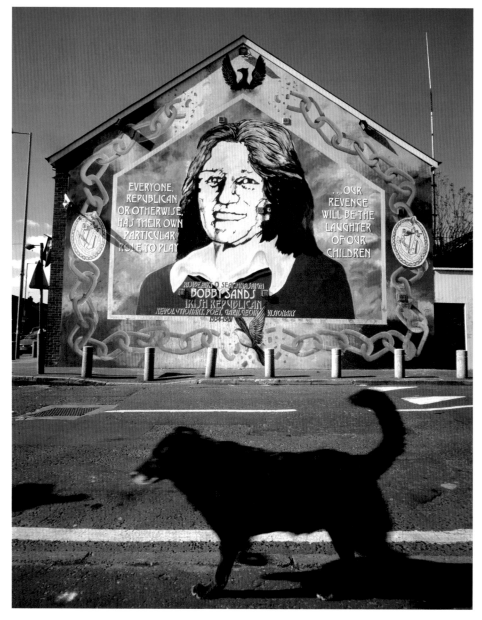

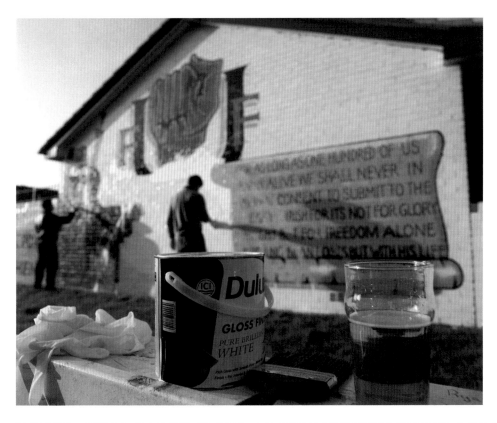

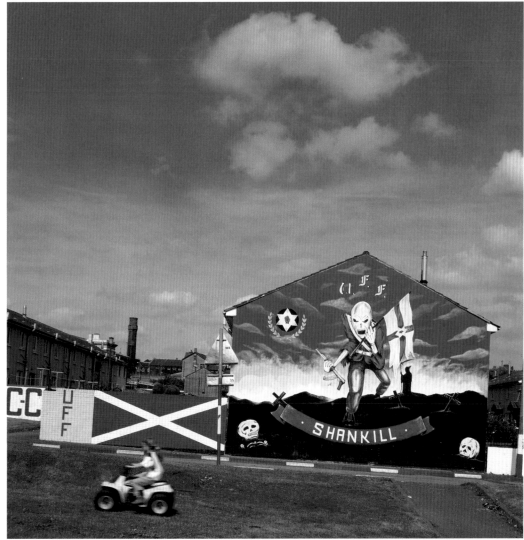

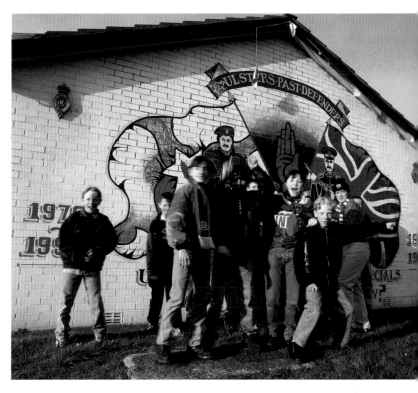

Loyalist murals

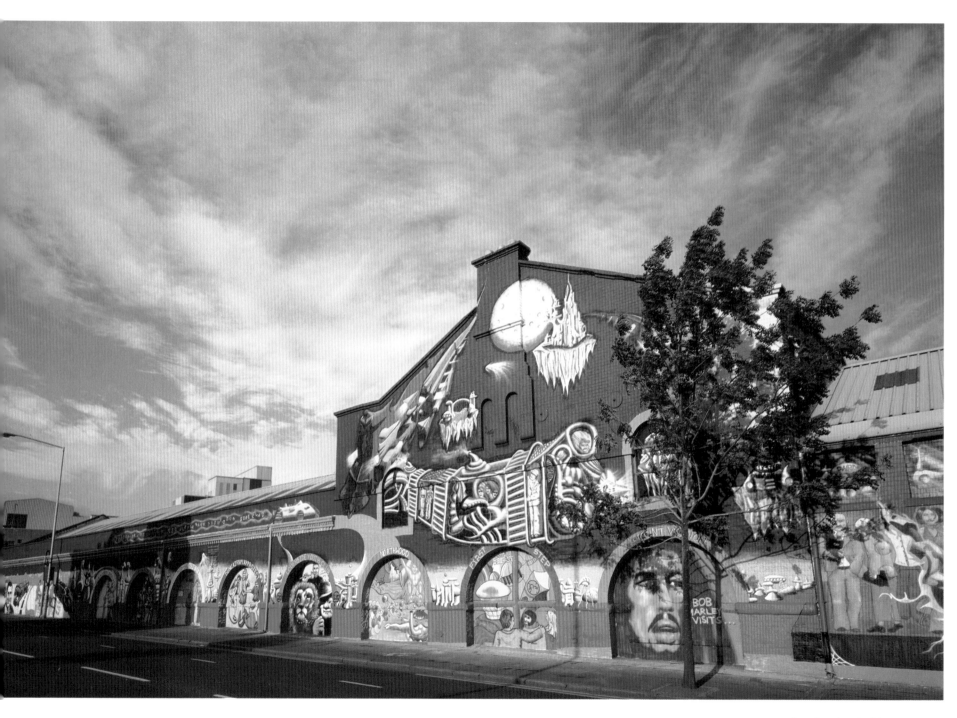

Another kind of hero:
Bob Marley community mural on York Road

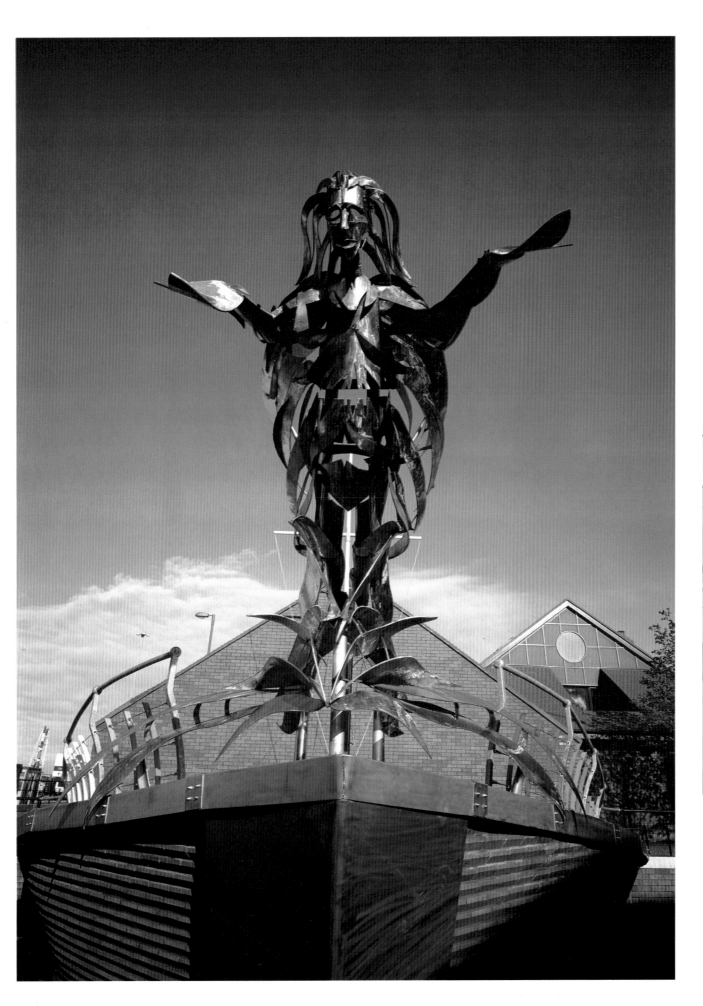

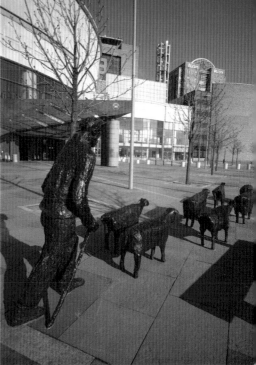

Above: Deborah Brown's evocative sculpture *Sheep on the Road* stands outside the Waterfront Hall.

Left: Flying Angel, a new sculpture by Maurice Harron, stands on a specially constructed ship's prow at the Mission to Seafarers on Prince's Dock Street.

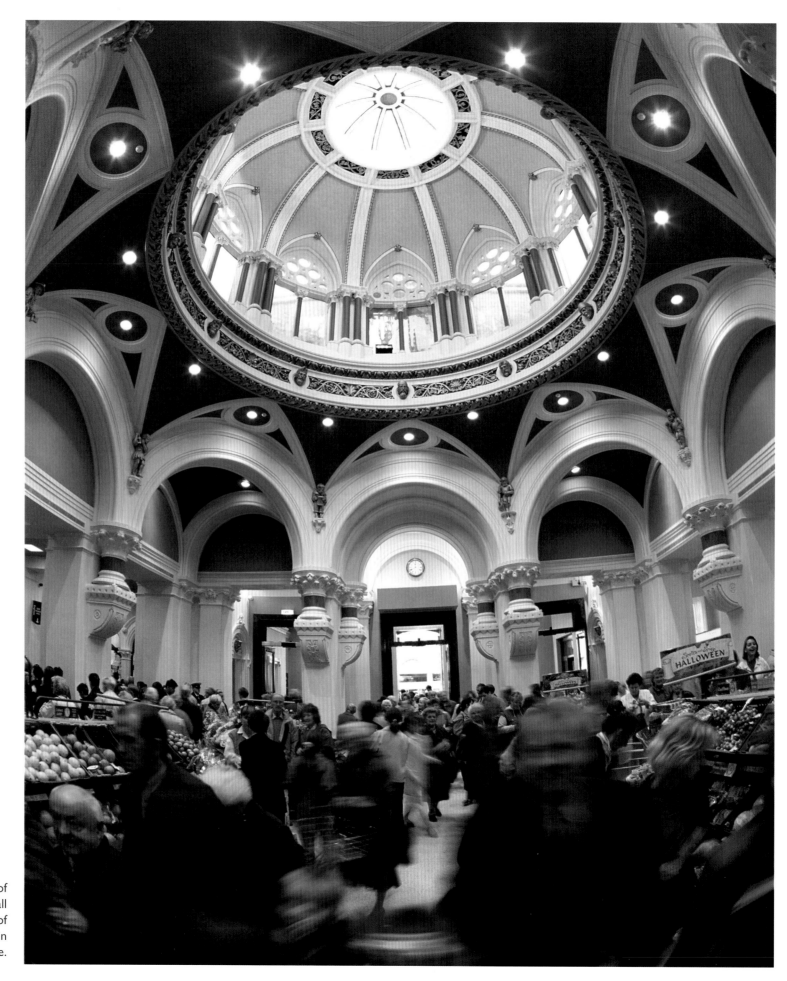

The ornate splendour of
a Victorian banking hall
is given a new lease of
life at Tesco Metro in
Royal Avenue.

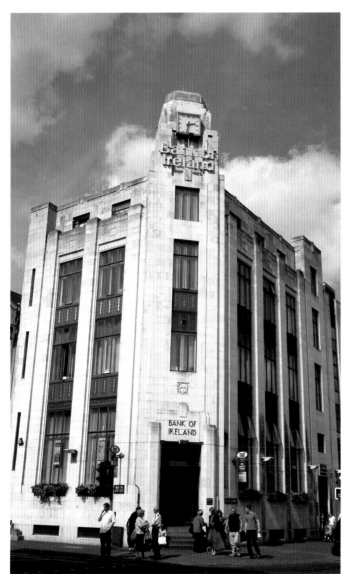

Left: The stylish Art Deco Bank of Ireland building at the corner of Royal Avenue and North Street

Below: The Northern Bank head office in Donegall Square West, with the City Hall's Garden of Remembrance on the right

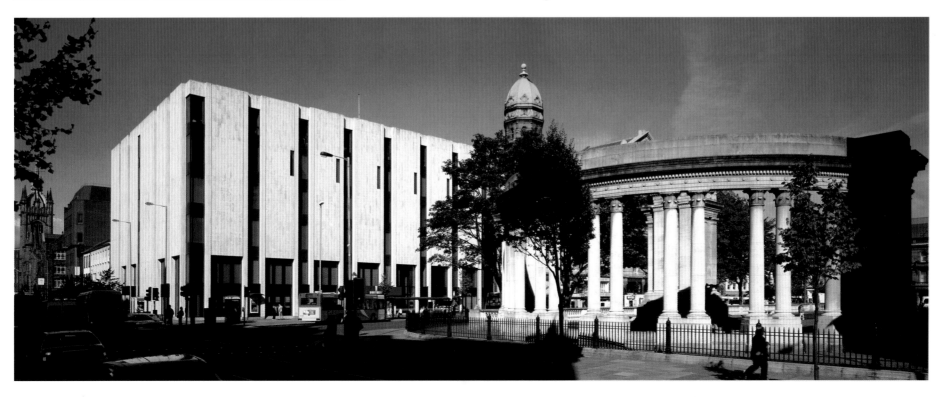

The Lagan flows dockwards between the tight
streets of the Lower Ormeau and the expansive
sweep of Ormeau Park.

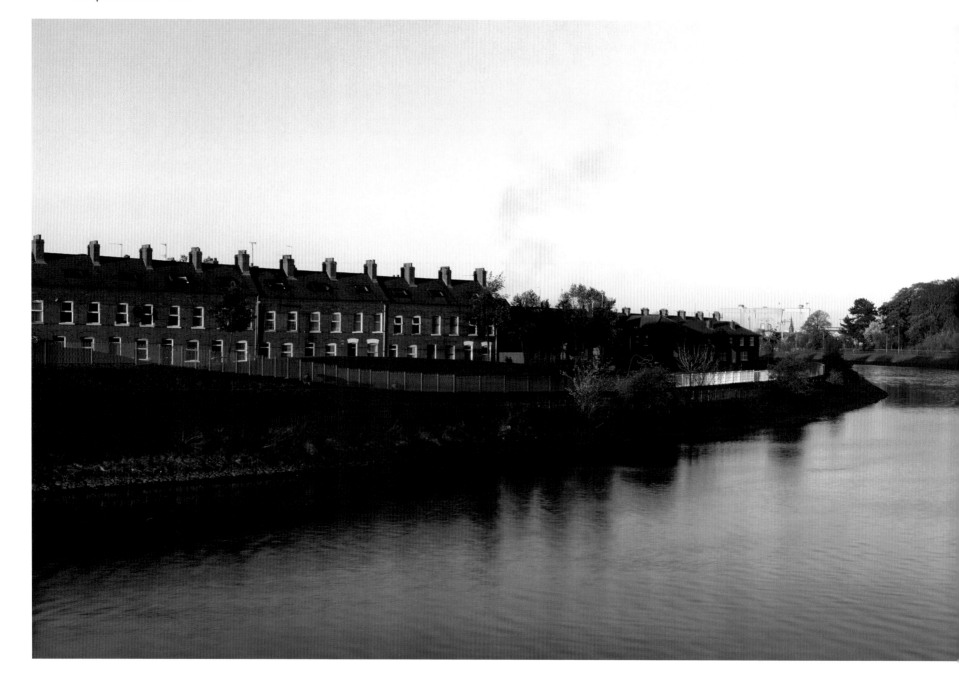

The old Gasworks at Lower Ormeau demonstrated Victorian confidence at its height. Today the Gas Office, with its familiar clock tower and ornate interiors, is being refurbished as part of an ambitious Gasworks development initiative.

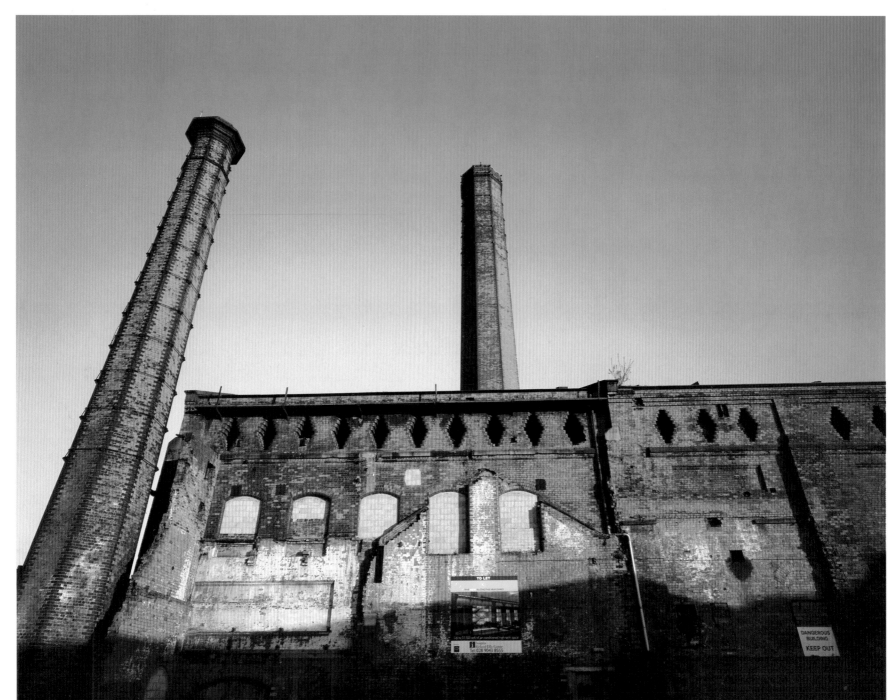

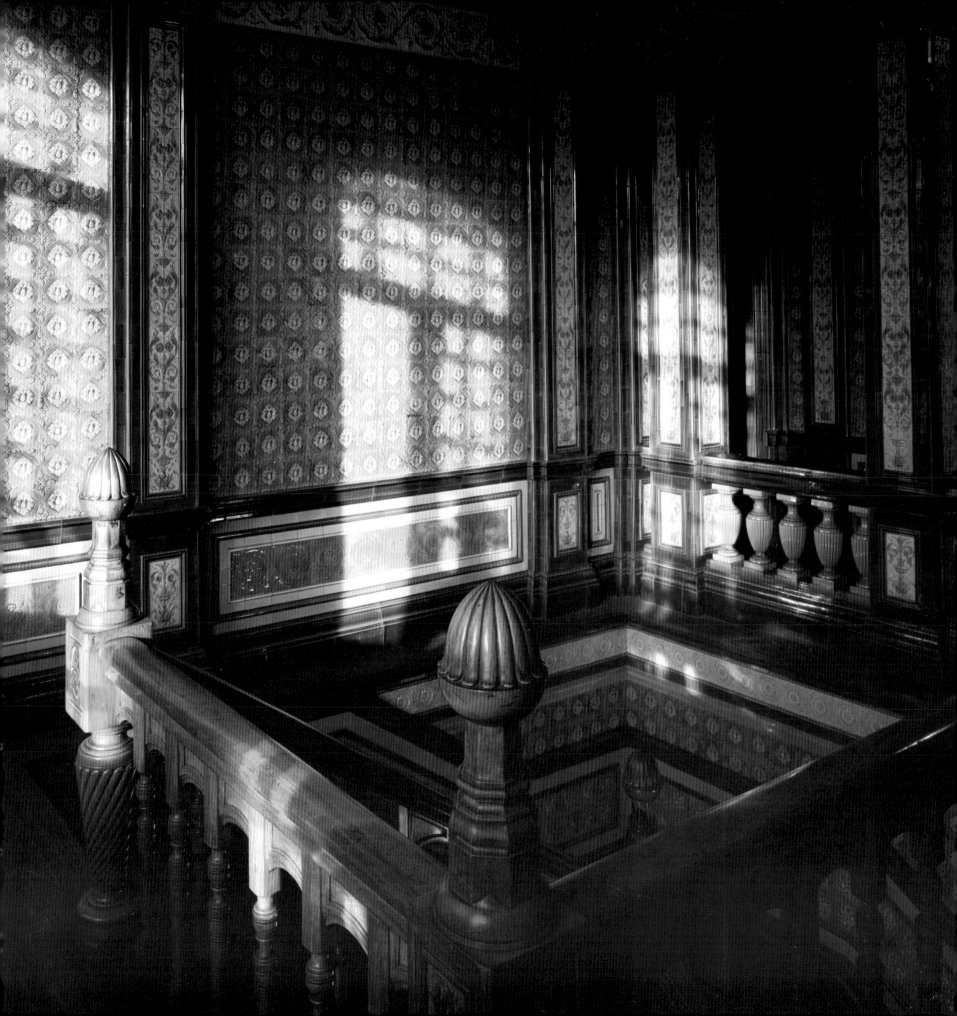

Opposite: Customers enjoy a quiet riverside drink at the Cutters Wharf Bar, Stranmillis.

Right: The entrance to Belfast City Council's extensive new development at the Gasworks site.

Below: This new building on the Gasworks site houses a UK-wide call centre for Halifax plc. The Tower Block of Belfast City Hospital can be seen in the distance on the far right.

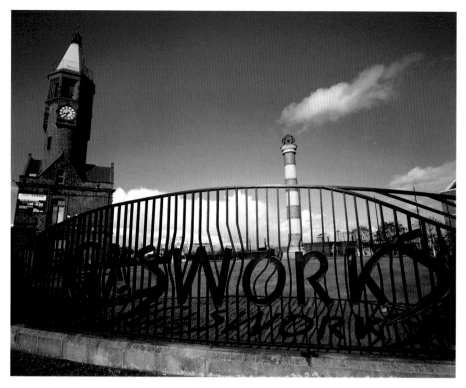

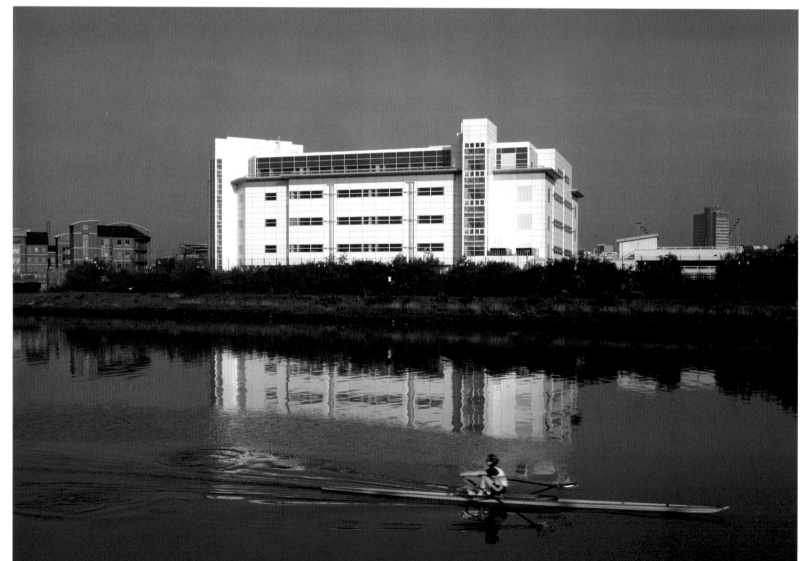

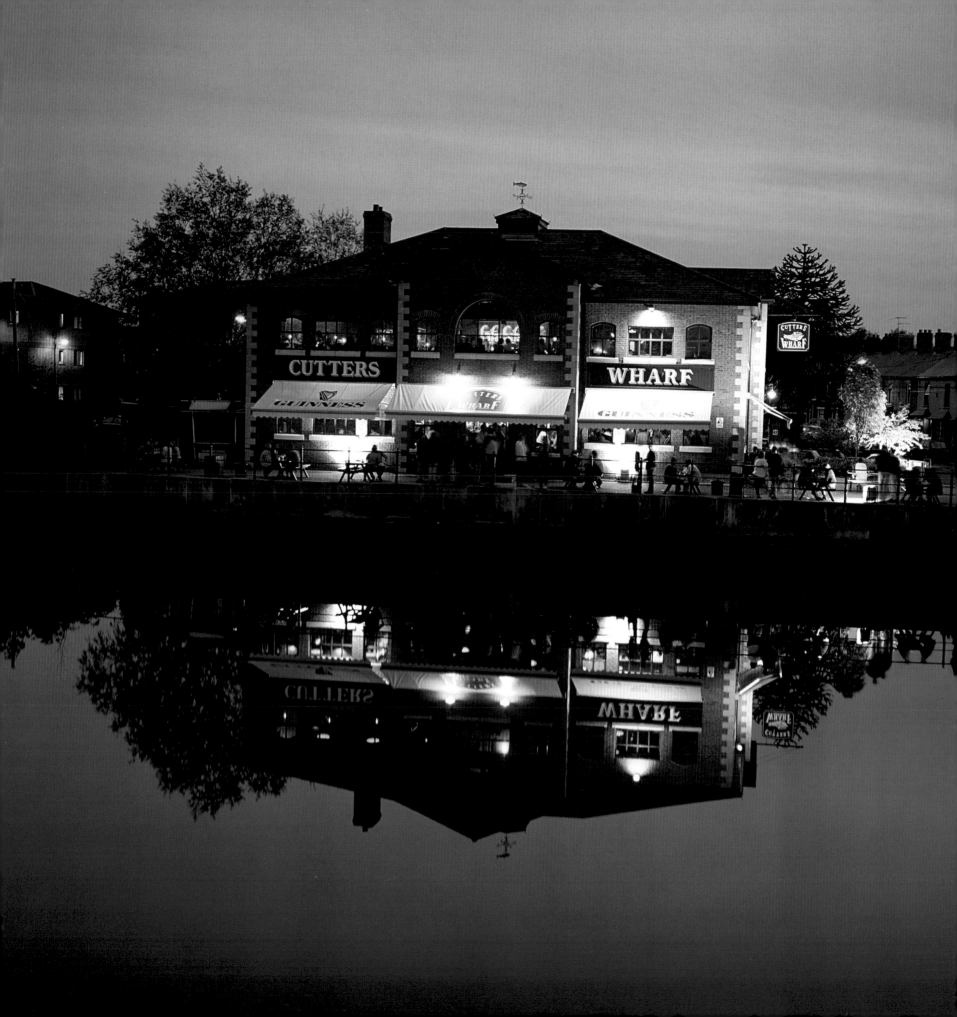

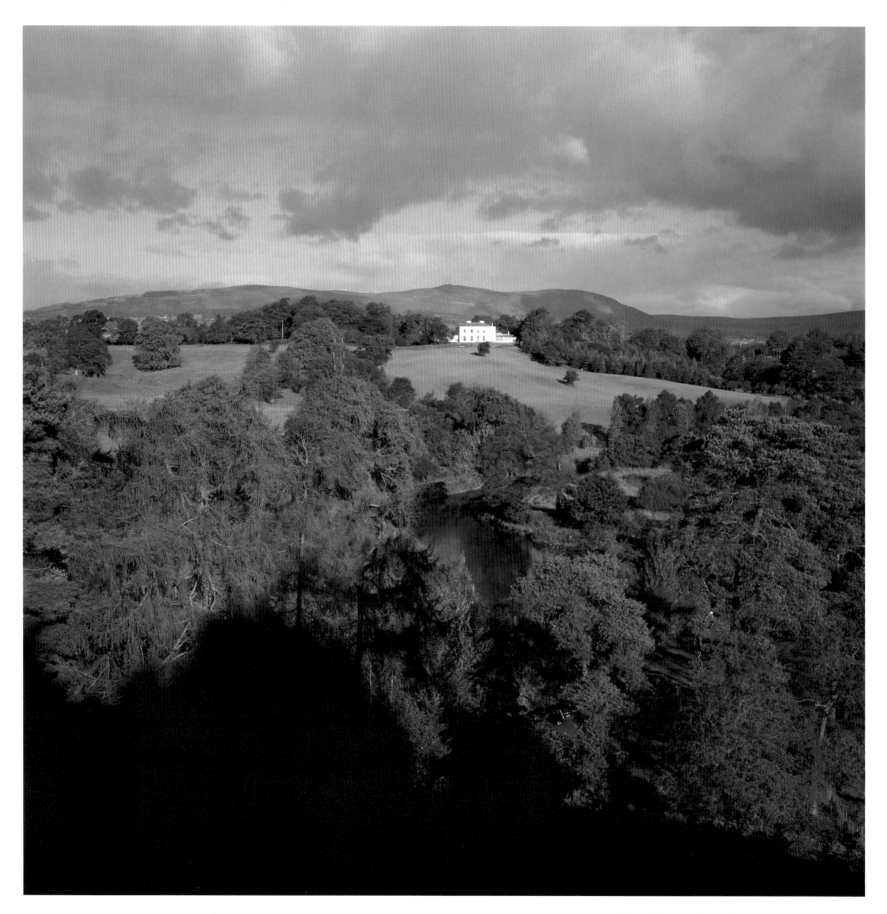

Above: Malone House, Barnett Demesne

Opposite: Autumn at Minnowburn

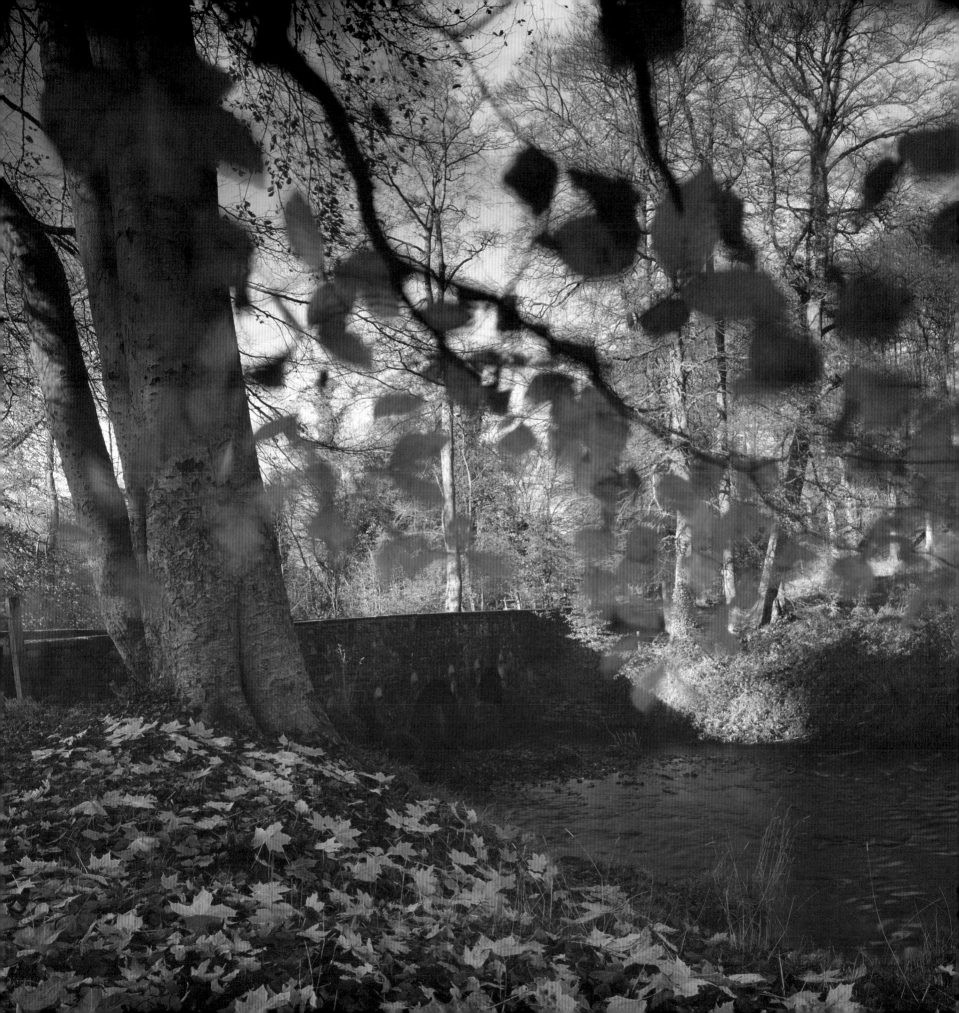

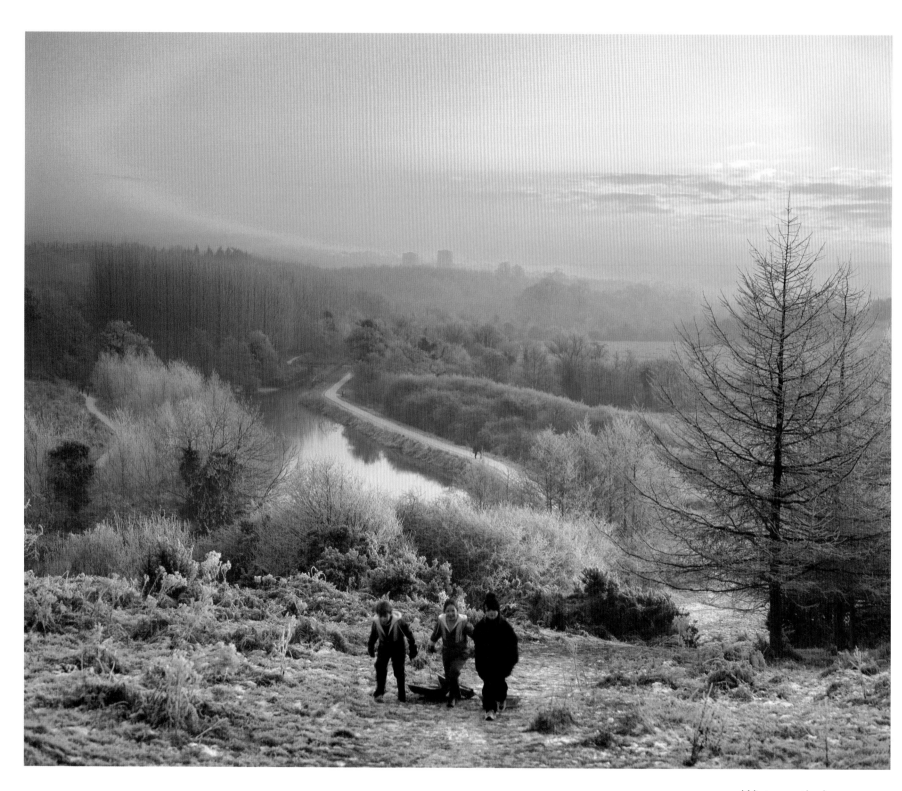

Winter on the Lagan

Above: Lagan Meadows

Opposite: Annadale

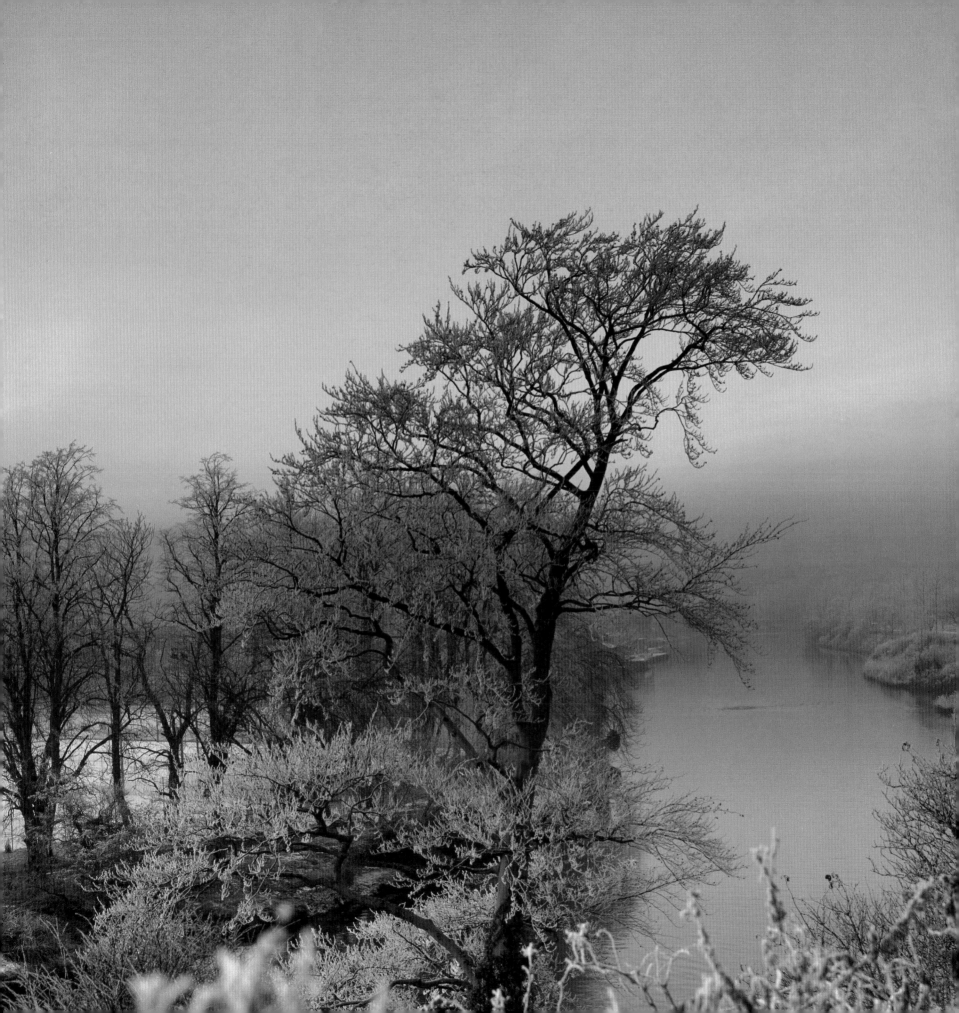

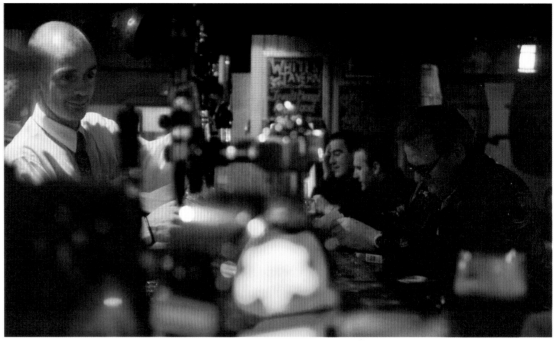

Belfast's lively pub scene

Right: White's Tavern, Lombard Street

Below: Traditional music session in
Madden's Bar, Smithfield

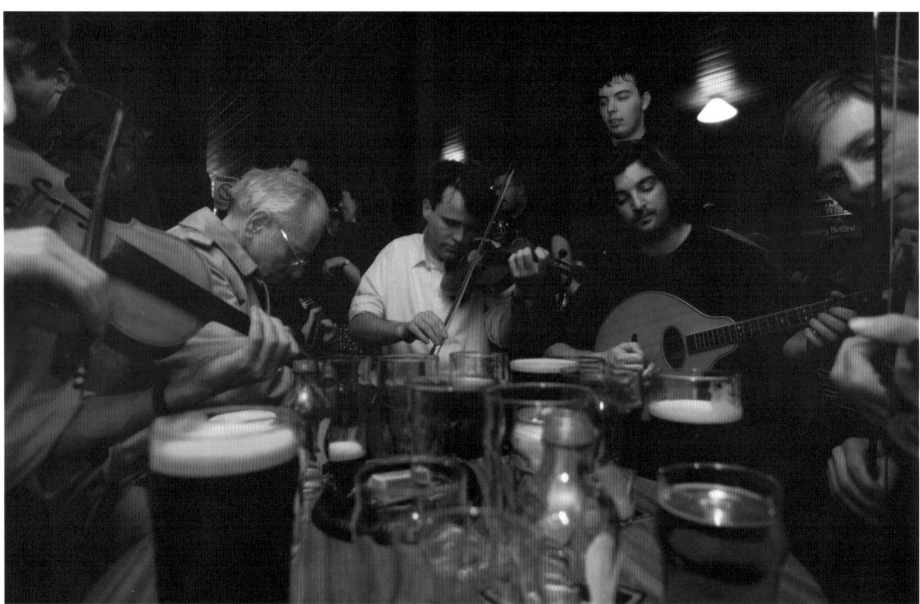

Entertainment at the Empire Bar
and Music Hall, Botanic Avenue

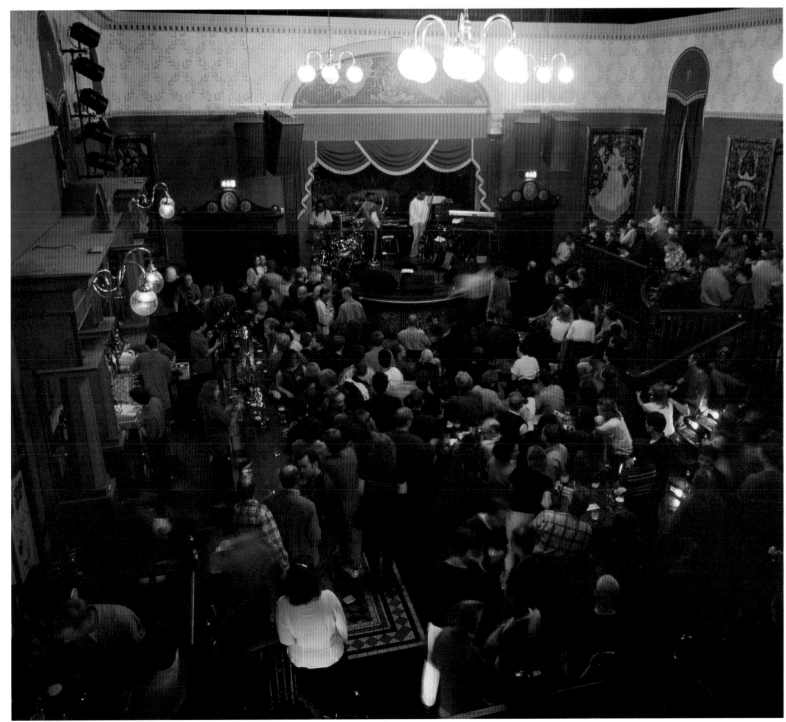

105

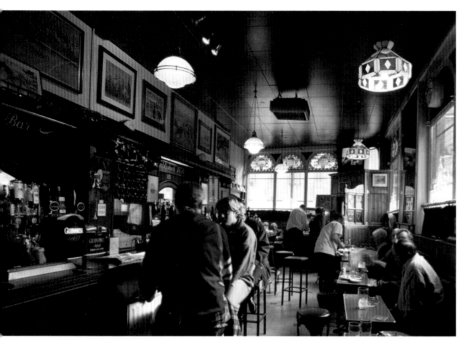

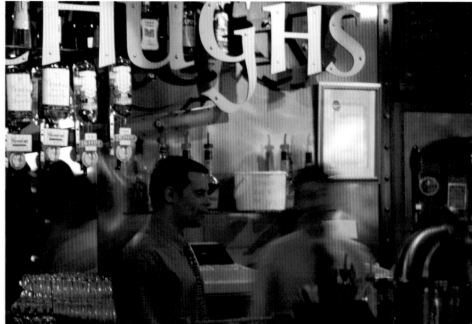

Top left: Kitchen Bar,
Victoria Square

Top right: McHugh's Bar,
Queen's Square

Right: Blackthorne Bar,
Skipper Street

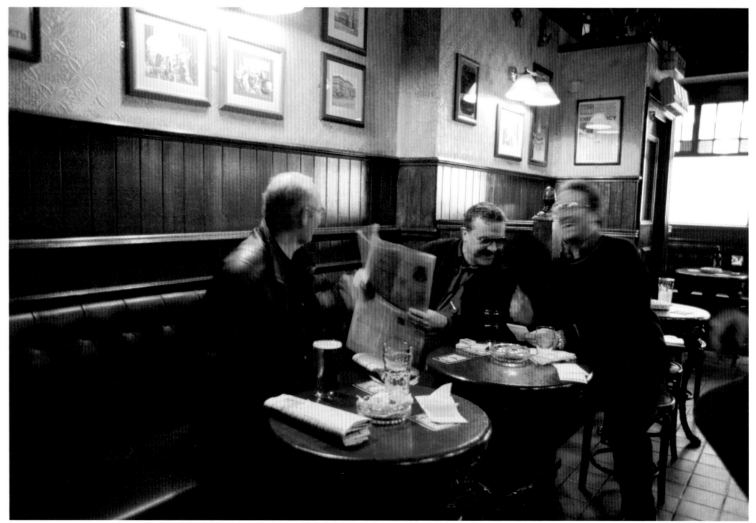

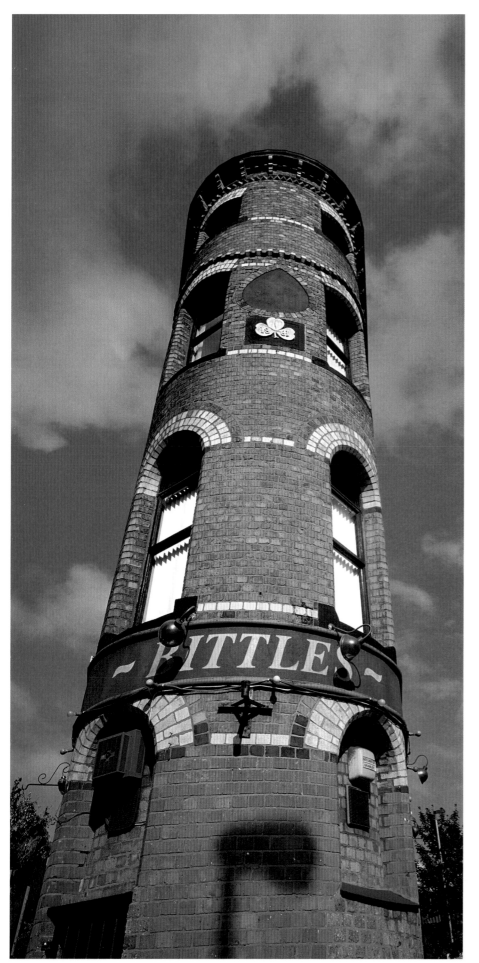

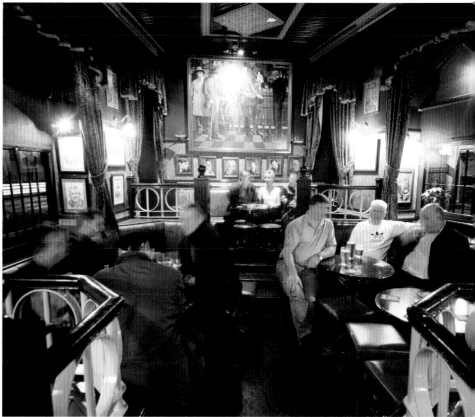

Left and above:
Bittles Bar, Victoria Street

Right: McCausland's Hotel, Victoria Street, is housed in a converted seed warehouse.

Below: Deane's Restaurant, Howard Street, with Michael Deane, *chef patron*

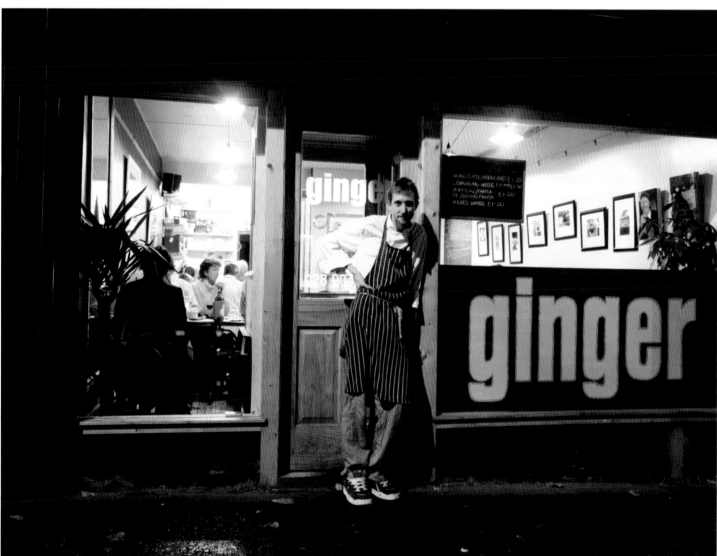

Left: Owner chef Simon McCance at the door of his Ormeau Road bistro, Ginger

Above left: The Northern Whig bar, Bridge Street

Above right: Cayenne restaurant (formerly Roscoff), Shaftesbury Square

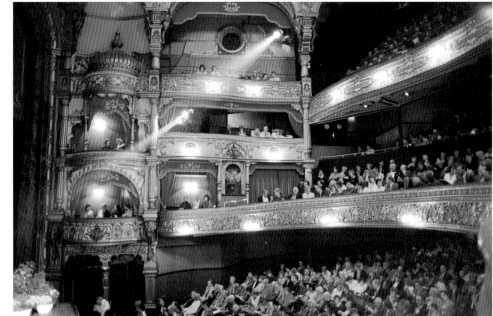

Belfast settles down for a
good night's entertainment

Right: The Grand Opera House

Below: The Ulster Hall

Opposite: The Waterfront Hall

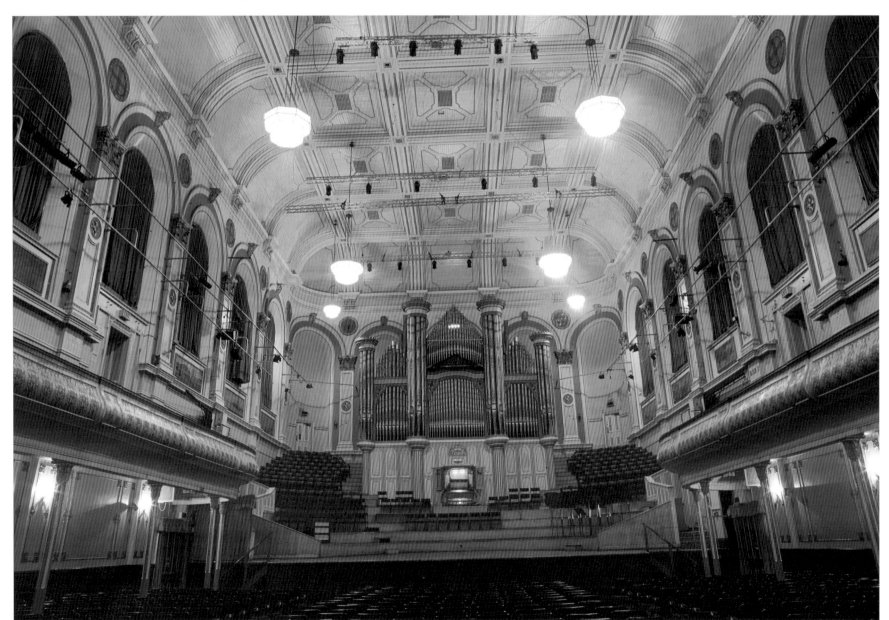

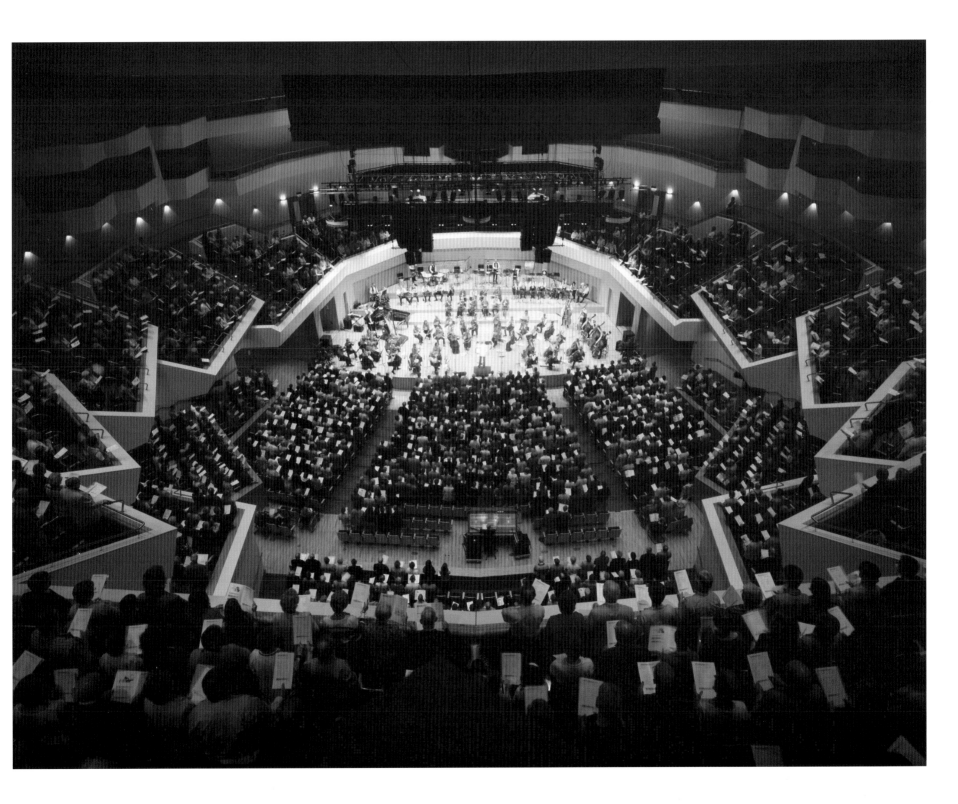

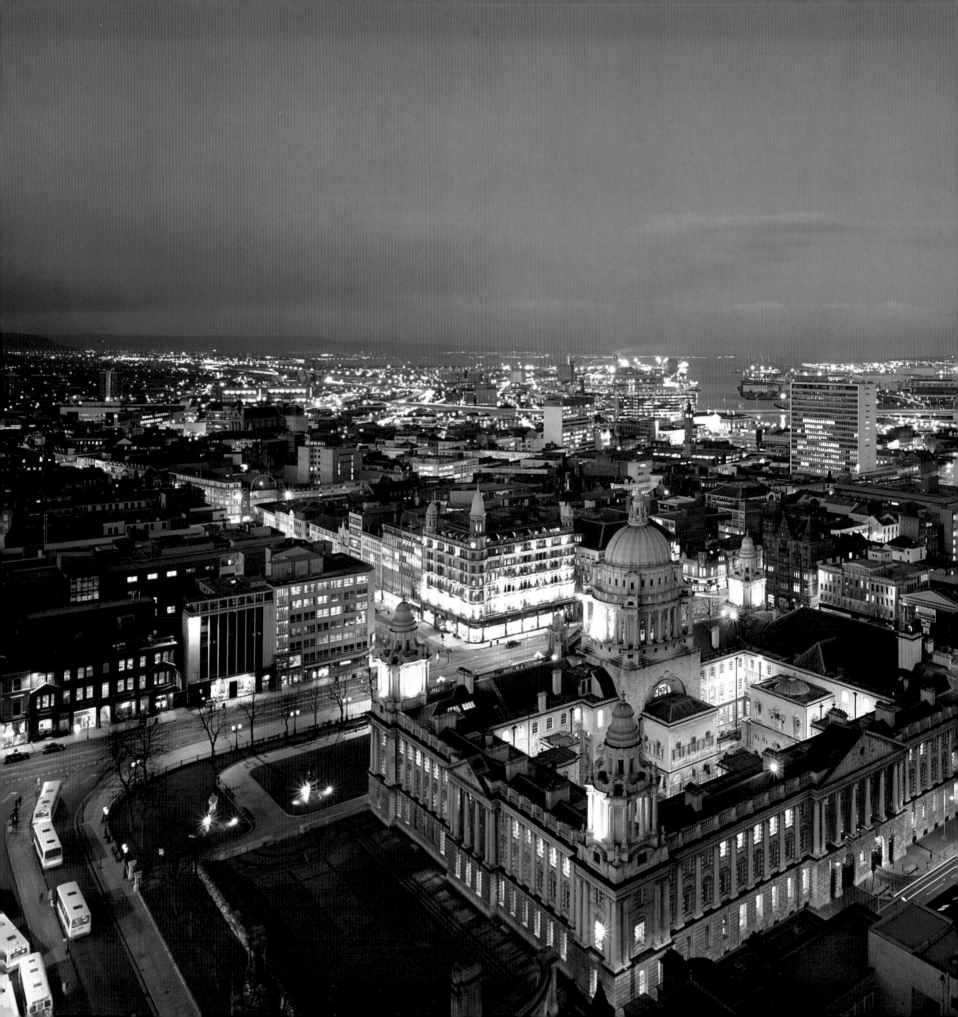

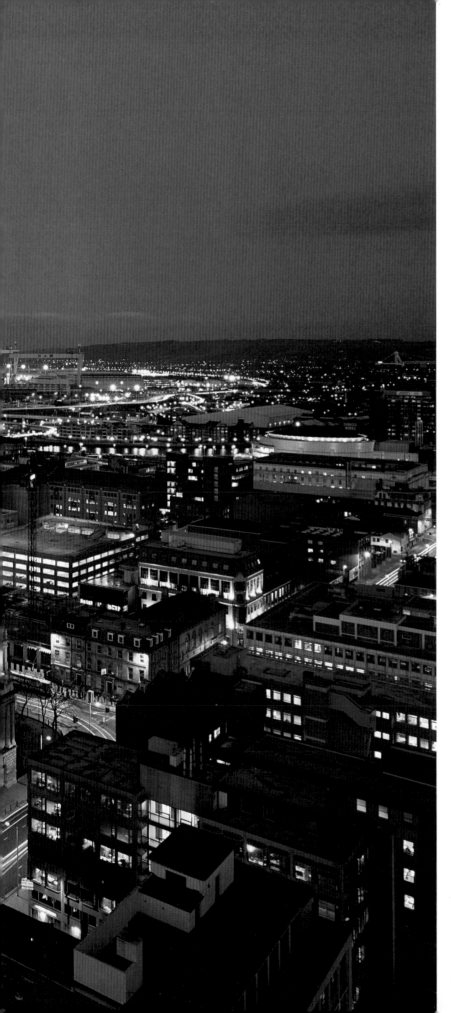

Night falls on city, docks and sea lough

The M3 bridge over the river Lagan, looking towards
the Antrim Hills with the Custom House and Lagan Weir
on the left and the Harbour Office on the right

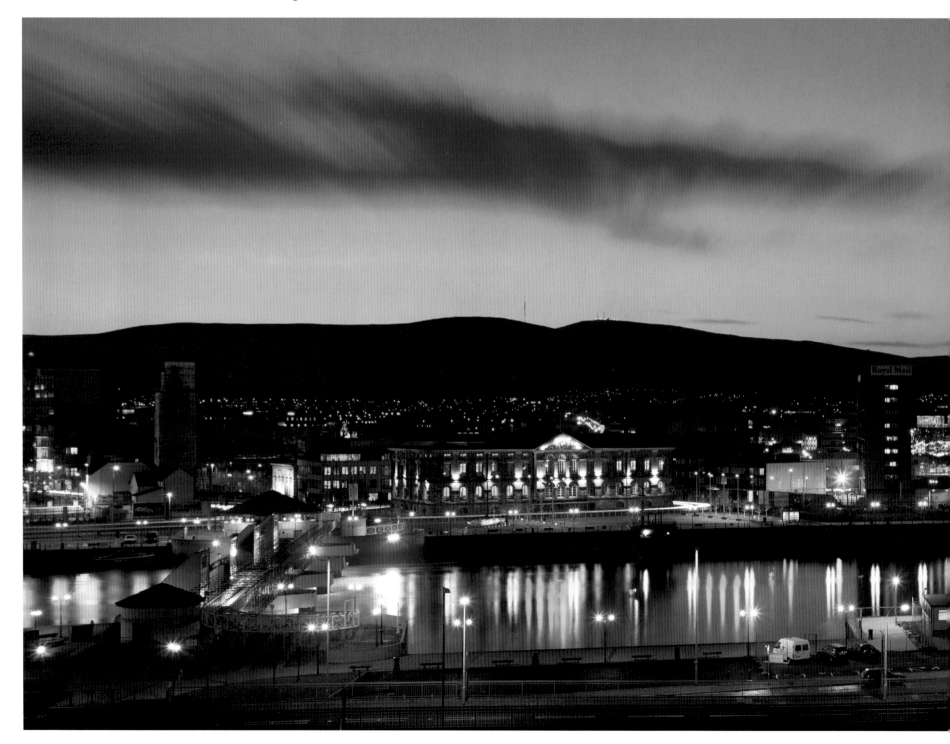

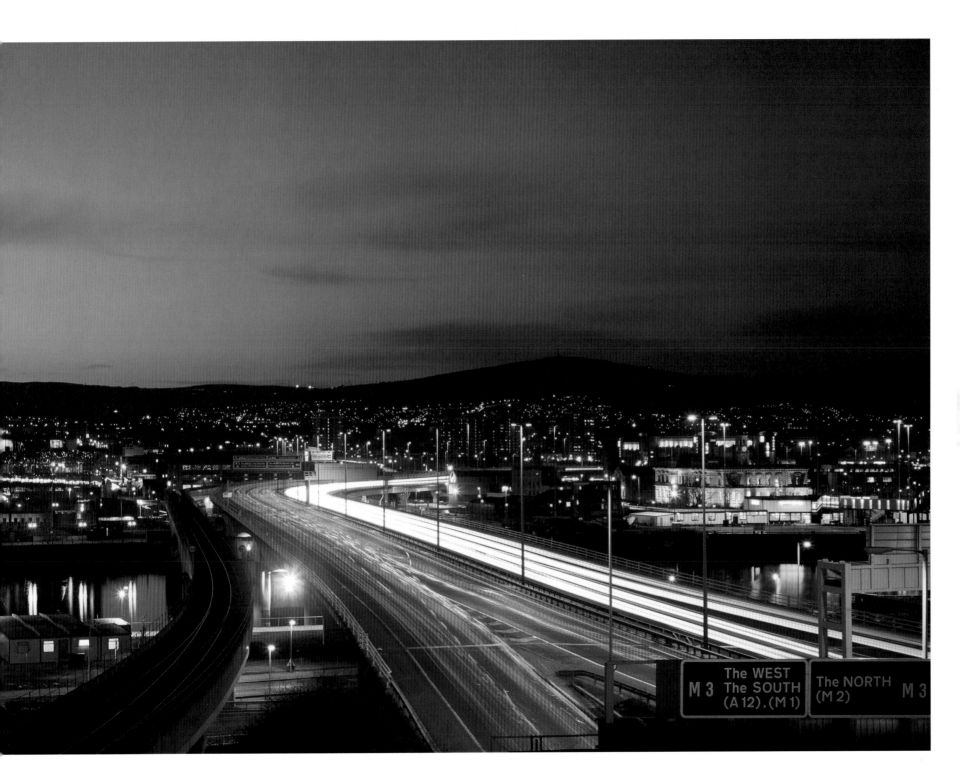

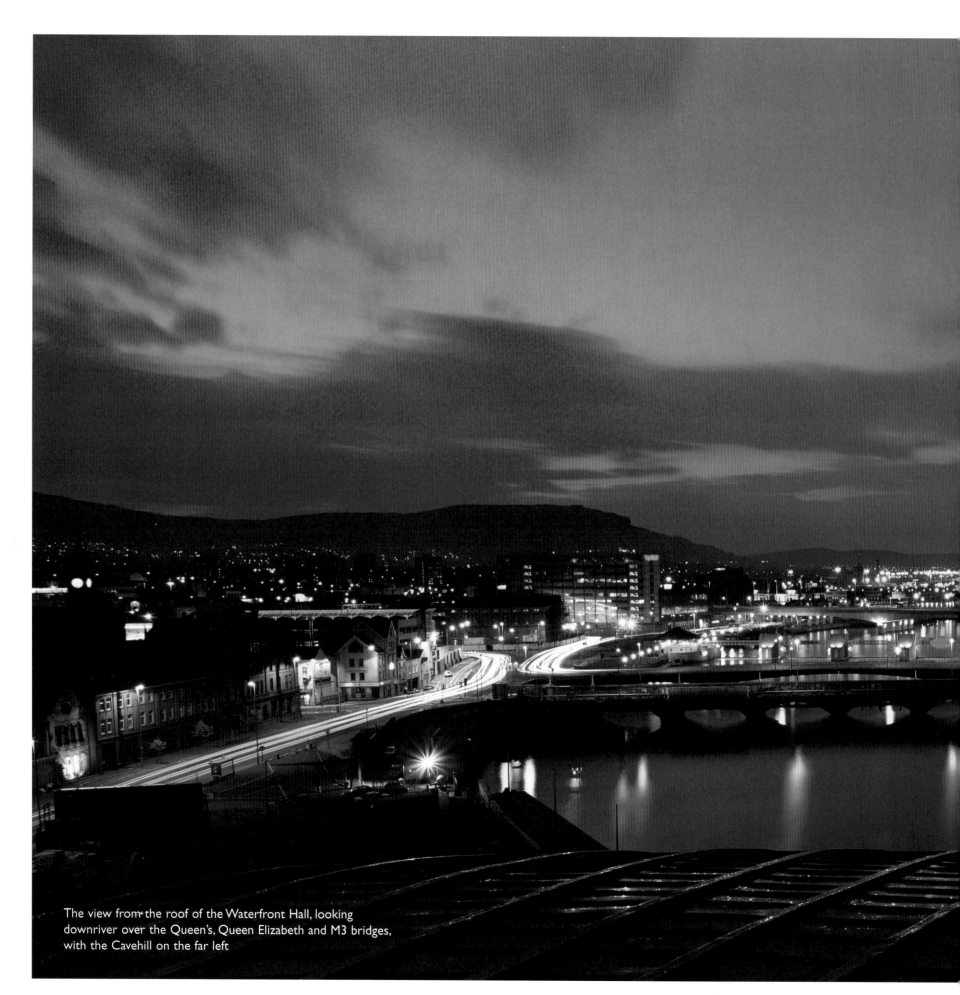

The view from the roof of the Waterfront Hall, looking downriver over the Queen's, Queen Elizabeth and M3 bridges, with the Cavehill on the far left

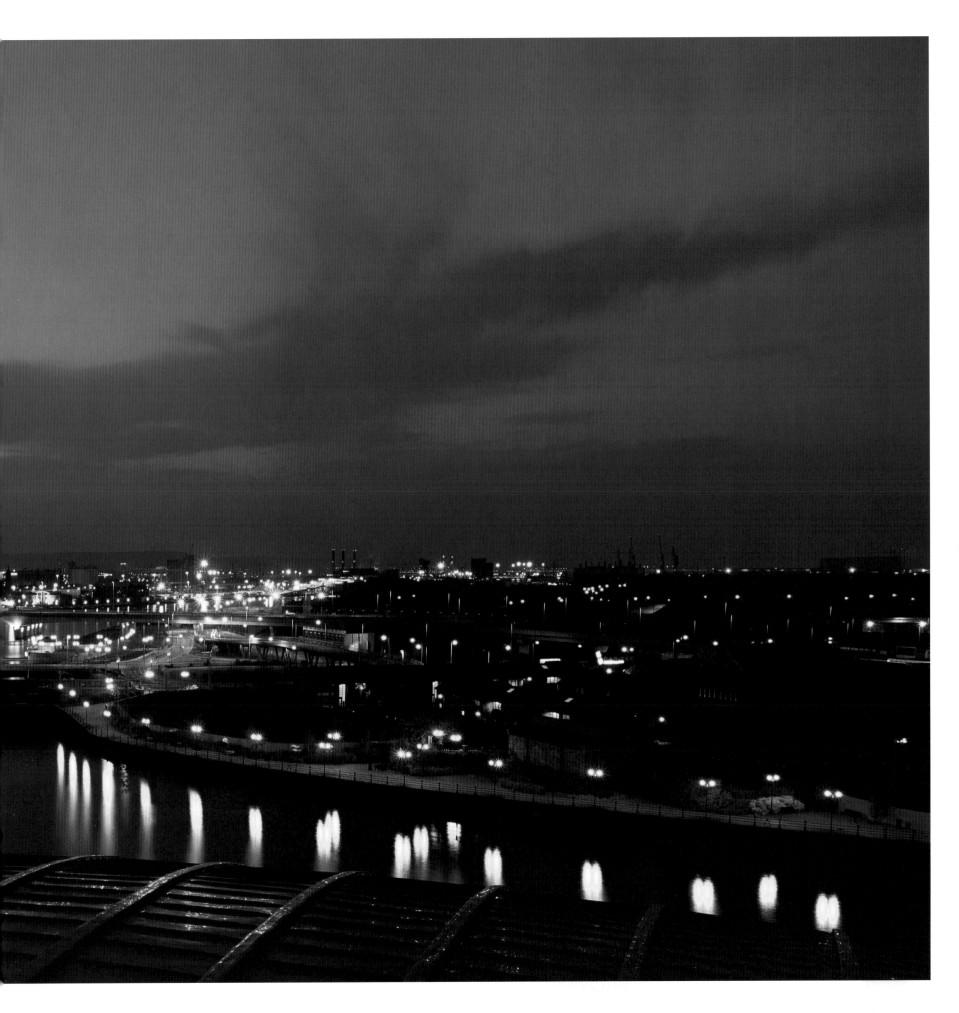

The city sleeps: the view from the Castlereagh Hills
across the Lagan to the County Antrim side

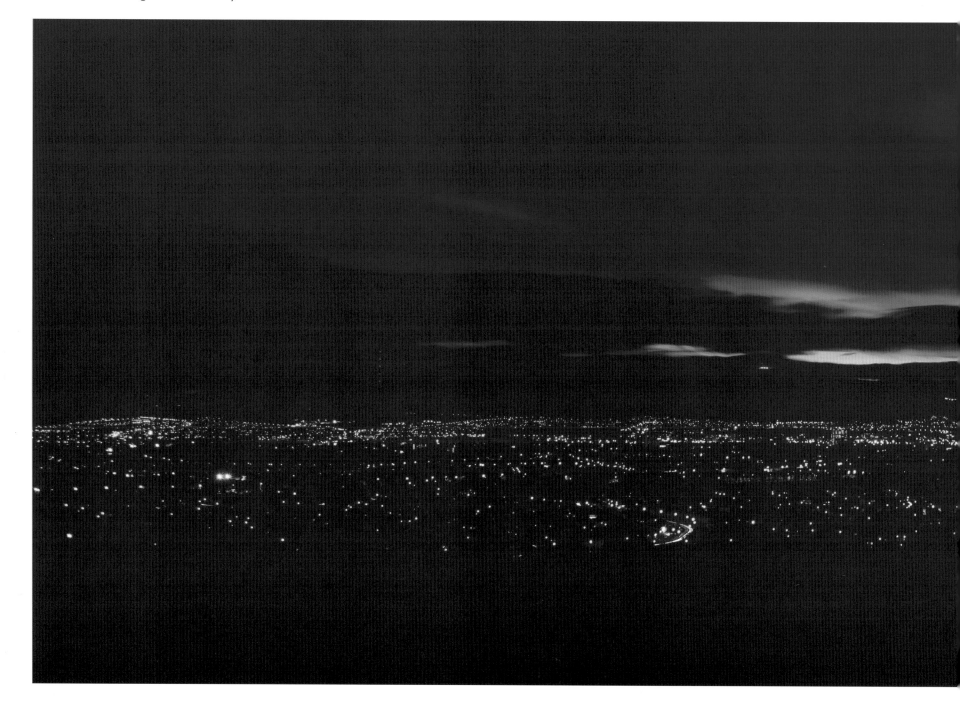

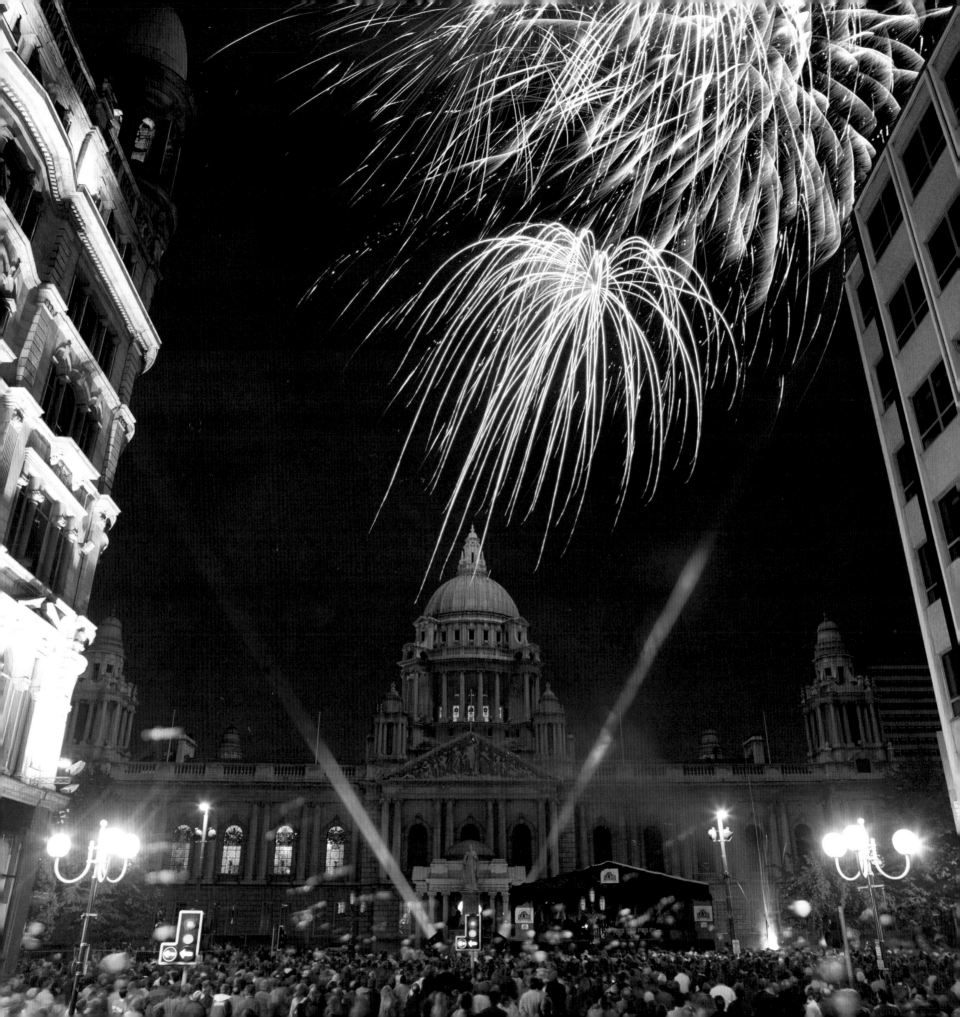